IMAGES
of America

SAN FRANCISCO
A NATURAL HISTORY

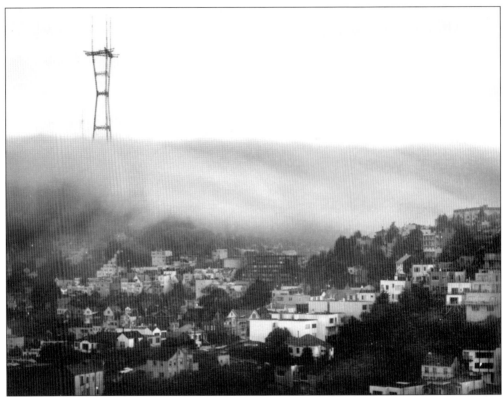

Summers in San Francisco are foggy because the cold and wet weather on the shoreline travels east toward the warmer areas of central California. With the city's microclimates and subtle seasons, the weather is hard to predict. During the summer, cold ocean currents carry warm northern weather south, and it often passes east of the city. Summer visitors prepared for "sunny" California are happy to find sweatshirts for sale at Fisherman's Wharf, where it can be unexpectedly cold and foggy. San Francisco is also not a place for ocean swimmers; surfers wear wet suits to ward off the cold. Generally, oceanic San Francisco is colder than the lands to the east, and the west side of the city is cooler than the east. But there are also many days of mild and pleasant weather. It does not rain much in San Francisco, and even when it does it is not usually torrential. San Francisco is a place where one can avoid the extremes of winter and summer, but these extremes can be found within a few hours' drive. The weather during the average day varies from sunny to foggy and windy, so one should dress for both the cold and the warm. The city's diversity of microclimates creates a unique diversity of plant and animal communities. Nowhere else on earth are there 47 square miles with drifting sand dunes, coastal prairie and coastal scrub plants, freshwater lakes, creeks, seeps and acquifers, oak woodlands, serpentine grasslands, perpendicular rock formations, saltwater estuaries, tidal marshes, and seven miles of beach facing the Pacific Ocean.

IMAGES
of America

SAN FRANCISCO
A NATURAL HISTORY

Greg Gaar and Ryder W. Miller

ARCADIA
PUBLISHING

Published by Arcadia Publishing
Charleston SC, Chicago IL, Portsmouth NH, San Francisco CA

Printed in the United States of America

Library of Congress Catalog Card Number: 2005929112

For all general information contact Arcadia Publishing at:
Telephone 843-853-2070
Fax 843-853-0044
E-mail sales@arcadiapublishing.com
For customer service and orders:
Toll-Free 1-888-313-2665

Visit us on the Internet at www.arcadiapublishing.com

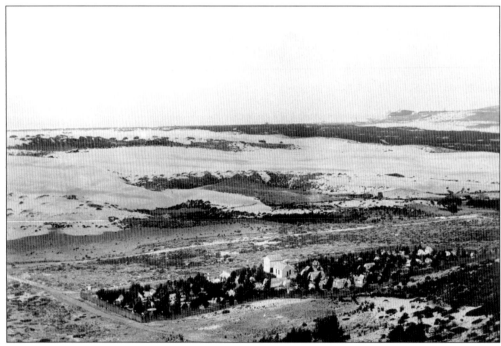

Carl Larsen's Chicken Ranch is in the foreground of this remarkable 1899 view of sand dunes in what would later be the Sunset District, looking northwest from Golden Gate Heights. Larsen was the owner of the Tivoli Café, and the ranch supplied eggs for many of the city's restaurants. Upon his death in 1928, "the gentle Dane" left many acres of land for the city's children. The intersection of Noriega Street and Nineteenth Avenue is at far left and Golden Gate Park is in the background. Much of the dunes were drifting sand and lacking in vegetation, but where there is surface moisture, deep-rooted dune vegetation has stabilized the advancing sand.

CONTENTS

ACKNOWLEDGMENTS

Special thanks to Pinky Kushner, Albert Kurz, Andrew Galvan, Alan Hopkins, Sue Smith, Ruth Gravanis, Josephine Randall Museum, the San Francisco Recreation and Parks Department Natural Areas Program, the Audubon Society, the Sierra Club, and the California Native Plant Society for their invaluable help with this project.

San Francisco summers are foggy, autumn is warm and sunny, and winter is clear and sunny, though rainstorms pass through the area. Spring is sunny as well, but the fog begins to materialize again. Most days, this mist will usually travel east over the city and will often burn off in the afternoon. (Greg Gaar photograph.)

PREFACE

EVOLUTION OF A SAN FRANCISCO NATURALIST

San Francisco was a fun place for a baby-boomer boy to grow up. Playland at the Beach, Fleishacker Pool, and Sutro Baths were run down, but still interesting places to go with your buddies. I can remember walking down the long stairway at Sutro baths and being awed by the hundreds of historic photographs of old-time San Francisco.

I've always been a San Francisco history buff and would spend evenings and rainy days at the main library going through old newspapers. For the 50-year anniversary of the 1906 earthquake and fire, the newspaper had special sections with photographs of the great disaster. Experiencing the excitement of the March 22, 1957, earthquake while in the second grade at Sunnyside Elementary School had a stimulating affect on learning about San Francisco earthquakes.

My grandfather went through the 1906 quake and attended the Panama Pacific International Exposition in 1915. I still have his PPIE Bluebook and his tickets to the fair. My mother and I would watch old movies together and my favorite is still the lavish Hollywood version of the earthquake, *San Francisco,* with Clark Gable as Blacky Norton, Spencer Tracy as Father Tim, and Jeanette McDonald singing "San Francisco." My family went to all the 49er games at Kezar Stadium, and I was named after a 49er, Garlin Gregory, from the 1947 team. Watching Y. A. Tittle throw "Alley-Oops" to R. C. Owens, or Abe Woodson running kickoffs back for touchdowns, or seeing Jim Marshall of the Vikings run 65 yards—the wrong way—after recovering a 49er fumble are etched in my memory.

But my real joy was playing, hiking, and biking on the vast open spaces of Mount Davidson, Twin Peaks, Glen Canyon Park, and Diamond Heights. During summer vacation, the neighborhood kids would scramble over the grassy slopes, playing cowboys and Indians, or slide down the steep hills on cardboard. We went to Silver Tree Camp in Glen Canyon Park and collected snakes, broke bottles, and climbed the rocky cliffs. In the evening, after the fog rolled in, it was a surreal time for a boy and his dog to hike on the undeveloped hillsides, savor the moist solitude, and think about life.

As a kid, I never thought that our unlimited play areas with tree forts, rock formations, and the fields with rabbits, garter snakes, and lizards—everything that we loved—would be destroyed. When I returned after four years in the navy in 1971, most of the wild spaces where I had played were developed. I was hurt and alienated. What was a playground for kids had become asphalt, concrete, and fenced backyards. When Tank Hill was threatened with the construction of 20 houses in 1977, I was committed to doing whatever I could to save the hill. I went door-to-door and stood at Cole and Carl Streets to convince residents to sign petitions and come to the hearing to convince city hall to acquire Tank Hill for a park. On September 28, 1977, with hundreds of people in attendance, the Supervisor's Finance Committee agreed to purchase Tank Hill. It was saved from the bulldozers, and my life would never be the same. It became a daily responsibility to hike to the rocky promontory and clean up broken bottles, cigarette butts, and dog feces. I researched and wrote about neighborhood history, pursued old photographs, and talked to old-timers about the good old days.

My love for the undeveloped land of San Francisco evolved when I met native-plant advocates such as Sue Smith and Jake Sigg. They opened my eyes to the beauty and importance of native plants and animals that had occupied San Francisco for millions of years. I saw the city and the world as an ecologist, ecology being the interrelationships of all organisms and their environment. I learned to manage the native-plant communities by removing weeds, and eventually to collect seed and propagate native plants. Today I manage a native-plant nursery at the Haight Ashbury Recycling Center in Golden Gate Park.

The Earth has evolved into a perfectly balanced mosaic of ecosystems and habitats as a result of complex relationships of climate, soil, plants, animals, and microorganisms. Yet our species is destroying this cosmic creation. Humanity has developed the technology to clear-cut the forests, dam the rivers, and in the words of Joni Mitchell, "pave paradise and put up a parking lot." Now we need to repair the damage that our species has inflicted on Mother Earth. Preserving and repairing our planet's ecosystems should be humanity's highest priority.

San Francisco has 350 species of native plants, 250 species of resident and migrating birds, 13 species of bats, and numerous species of mammals, reptiles and amphibians. The city is part of the Franciscans Biological Region (Montara Mountain to the Marin Headlands), which is classified as a Biological Hotspot by the United Nations. Additionally, San Francisco is a vital resting spot along the Pacific Flyway for migrating birds. The natural areas of San Francisco are an important feature in the "web of life" of the planet and must be protected. Our species has an opportunity to repair our mistakes, and habitat restoration is a big part of that opportunity.

San Francisco is a microcosm of the entire planet. The philosophy of the environmental movement has always been "Think Globally and Act Locally," so let's begin where we live— San Francisco.

—Greg Gaar, 2006

INTRODUCTION

In *San Francisco Stories*, John Miller writes that San Francisco, a postcard town, is "everybody's favorite town." But the city was not always considered scenic, and had parts that were considered unlivable. Richard Henry Dana, in *Two Years Before the Mast* (1840), saw the potential of the area but used words like "dreary," "barren," and "ruinous" to describe it.

San Francisco has been more than just a tourist attraction. It was once the most significant city on the West Coast and is still arguably one of the most important cities in the world. San Francisco has a long cultural history, but also of interest is the bittersweet natural history story of the settler's encroachment on the local habitat, and the eventual efforts to protect the remaining pieces of native lands. Boasting many lovely natural and manmade landscapes, San Francisco is one of the most beautiful cities in the country, but very little of its original native habitat remains.

In *The Ohlone Way*, Malcolm Margolin recounts how the Ohlone Indians once lived bountifully on the peninsula and around the bay on a land area that supported elk, antelope, grizzly bears, salmon, condors, and pelicans. The physical habitat of the area consisted of grasslands, rivers, marshes, wetlands, lakes, and redwood forests. The Ohlones did not need conservation practices to preserve the habitat and wildlife that they depended upon. Nor did they need to establish formal agricultural practices, depending instead upon the traditional hunting and gathering and controlled burnings.

Though the Bay Area still maintains a liberal community, there is also an "imperial history" of San Francisco, explored by Gray Brechin in *Imperial San Francisco*, which recounts the mass alteration of the surrounding land. The early Western settlers sought to create a city that rivaled the power of Rome. San Francisco became a military staging post for the newly formed nation of America that sought to dominate two oceans.

Responding to the gold rush, the outlying areas of the bay served to supply the city with its necessities, and were laid to ruin in a time before the idea of conservation became accepted. Forests were cut down, tributaries to the bay were polluted with sediment, and the precious Hetch Hetchy Valley was dammed to supply San Francisco with water. Urban encroachment destroyed 95 percent of the wetlands of San Francisco Bay, and whole areas of the city that were originally sand dunes were eventually paved over or turned into parks. Many years after efforts were made to "beautify" San Francisco in order to attract settlers to the area, people now mourn the loss of the natural environment and hope to recreate the habitat to support the wildlife that once thrived in the city.

San Francisco and its environs have a rich cultural history, being the home of some of the most environmentally concerned writers the country ever produced, including John Muir, John Steinbeck, Jack London, Gary Snyder, Lawrence Ferlinghetti, Harold Gilliam, and Wallace Stegner. The San Francisco Barbary Coast was once an unruly place that San Francisco Renaissance poet

Kenneth Rexroth wrote was settled by "gamblers, prostitutes, rascals, and fortune seekers." Less than a century after the gold rush, the beatniks, and later the hippies, were drawn to the area. But environmentalists, artists, and bohemians could not stem the actions that would turn the west end of the city into the Doelgerville housing settlement (the Sunset District) and encroach upon the bay's wetlands.

The Habitat Restoration Movement seeks to repair damaged natural areas and recreate lost habitats. The process poses difficult questions pertaining to what the native areas were originally like, where historical lines should be drawn for restoration efforts, and what should be valued, and therefore restored.

The work needed to refurbish the native habitats need not be extremely complicated. Decisions can be made as to what habitats and wildlife can be accommodated in the urban metropolis, and then efforts can be made with those goals in mind. Grizzly bears cannot be brought back to San Francisco, but the Raven's manzanita can be propagated, the habitat for Western snowy plovers can be protected, and certain weedy plants can be removed to restore the habitat that once existed. Habitat restoration allows naturalists the opportunity to reconnect with the past and allows urban people to connect with the earth.

Reacting to waves of newcomers to the city, various San Francisco communities have made efforts to reclaim the city. As James Brooks, Chris Carlsson, and Nancy J. Peters note in *Reclaiming San Francisco: History, Politics, Culture,* local restoration efforts are part of a larger movement to reconnect with the city's "contrarian" spirit. Attempts have been made to discourage some newcomers because they have traditionally degraded the land and raised the rental and home prices. George Berkeley's invocation in 1726, "Western the course of empire takes its way," no longer applies. The lonely and natural areas will still welcome newcomers, however, even if the city resists them. The natural areas of San Francisco are still wonders to behold.

Presented here is San Francisco's Natural History, a bittersweet tale about what has been lost and what can still be restored. Greg Gaar, a San Francisco native, local historian, and natural-areas advocate, will share the evolution of San Francisco's natural landscape. I, Ryder W. Miller, a former interpretive park ranger, naturalist, and local environmental reporter, will share some of the natural wonders that can still be found in the increasingly paved-over city of San Francisco.

—*Ryder W. Miller, 2006*

One

THE SAND DUNES

There lies a wild, free stretch of desert land between the lashing sea and rugged hills. A place where I have loved to go and rest, and think of God and sky and sea and land. And sink close to earth's bosom and be blessed, a friendly place gone now before the builder's hand. I want the sand dunes to escape the streets, I want to go where nature's heart still beats.

—Roselle Hansen, "Sand Dunes," Polytechnic High School, 1931

San Francisco once had one of the world's largest concentrations of ocean-produced sand dunes. Many factors, such as the relentless Pacific waters and the erosion of the Sierra Nevadas that brought granite sand into the bay, created this phenomenon. Prevailing northwesterly winds eroded the western shore and blew the sand inland over time. Starting 15,000 years ago with the end of the Ice Age, the climate warmed and sea level rose 350 feet, forcing the sandbank further inland. Amazingly, just a mere 12,000 years ago, one could walk to the Farallon Islands. Back then, the bay was a river valley with today's bay islands rising as tall hills surrounded by rivers, creeks, and lakes.

As sea level rose, the sand dunes advanced inland and climbed up and over the 800-foot intercoastal range of Golden Gate Heights, burying grasslands, scrub, and chert rock formations. Throughout this ocean of sand were hills over 100 feet tall, which would be leveled to make way for urbanization. As early as the 1860s, temporary railroads called "steam paddies" were constructed to carry the sand to Mission Bay and Yerba Buena Cove where it was used to fill the marshlands and estuaries to create buildable lots.

San Francisco's sand dunes were never a "barren sand waste." When the dunes were stabilized by deep-rooted dune vegetation, a diverse and beautiful native plant community supported many species of insects, birds, reptiles, and mammals. Coastal dune scrub communities can be seen today at Fort Funston, above Baker Beach, Lobos Creek Valley, and Hawk Hill.

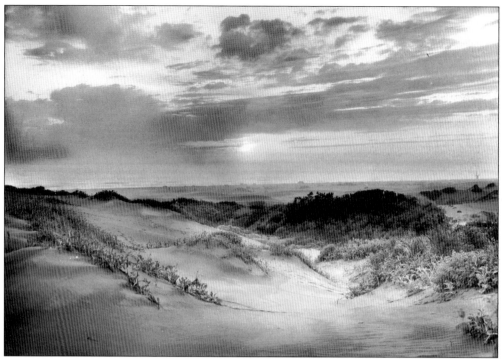

A *c.* 1910 Willard Worden photograph looks west to the ocean near the present site of Sunset Boulevard. Carville, a residential community of discarded streetcars, and the Dutch Windmill are barely visible in the background. (Marilyn Blaisdell Collection.)

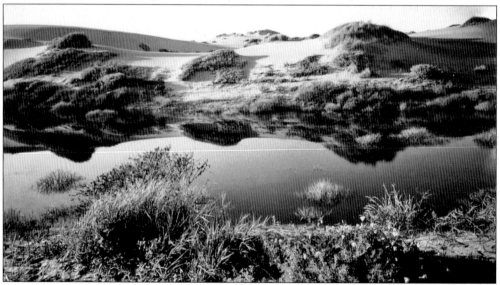

Another *c.* 1910 Willard Worden photograph shows an inter-dune pond in the future Sunset District. Freshwater ponds and lakes like this one were not uncommon in San Francisco's sand dunes, especially during the rainy season. Wildlife need freshwater to survive. Before Golden Gate Park was developed, 14 native inter-dune lakes existed within the area's 1,013 acres. All of the native lakes were filled except the Chain of Lakes, and manmade bodies of water replaced the natural lakes. A close look at this photograph reveals small animal prints in the sand. (Marilyn Blaisdell Collection.)

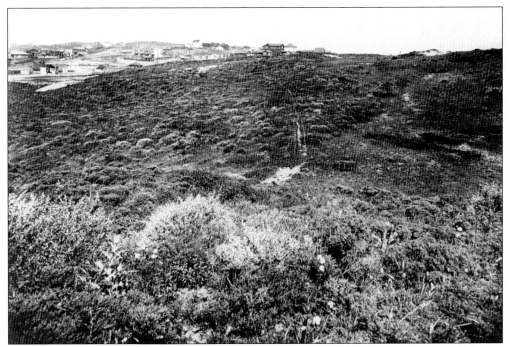

The Outer Richmond, seen in this 1910 image looking northwest from Balboa Street and Thirty-second Avenue, had dense dune scrub foliage that naturally stabilized the drifting sand. Some of the plants visible in this photograph include the dune tansy, the sticky monkey flower (*Mimulus aurantiacus*), the coyote bush (*Baccharis pilularis*), and the San Francisco wallflower (*Erysimum franciscanum*). The dunes were not a "barren sand waste," as they were sometimes called, but a rich, diverse habitat. Today the site is all streets and housing.

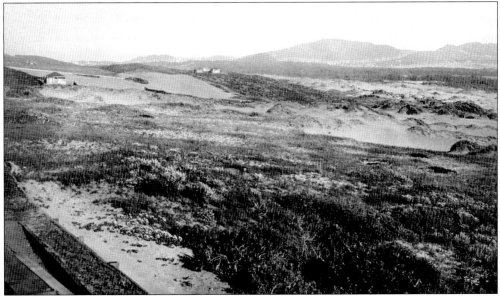

Looking southeast across the Outer Richmond, this c. 1910 photograph shows drifting and stabilized dunes. Golden Gate Park is in the valley with Mount Sutro (the large forested hill) in the center, and Golden Gate Heights at right in the background.

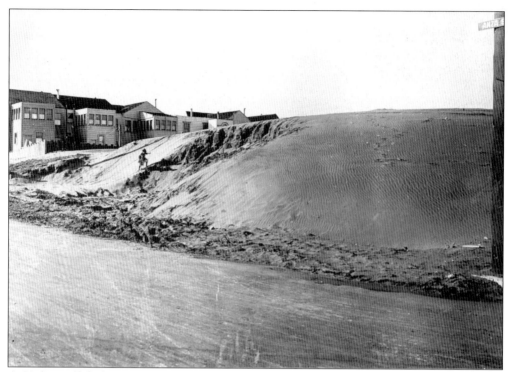

A 30-foot-tall drifting sand dune covers the vacant lots on Anza Street between Eighteenth and Nineteenth Streets in 1914. A little girl climbs over the sand, carrying her dolly with the aid of a walking stick.

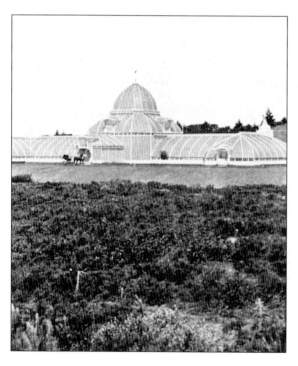

The Conservatory of Flowers in Golden Gate Park is seen here, shortly after its completion, with the native dune plants covering Conservatory Valley plainly visible. These species of vegetation existed for thousands of years in this same location. They were drought-tolerant and required no maintenance. Plants such as the monkey flower, the beach sagewort (*Artemesia pycnocephala*), the San Francisco wallflower, and the lupine (*Lupinus chamissonis*) are beautiful and support numerous species of insects, birds, and other wildlife. Today Conservatory Valley is planted with exotic, high-maintenance, annual flower beds, and displays are replaced seemingly on the whims of management. The exotic plants are not sustainable, drought-tolerant, or attractive to native wildlife, but they are photogenic for tourists.

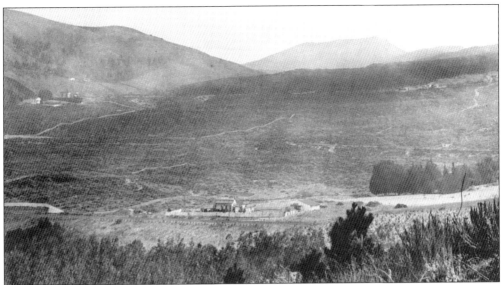

An 1886 image shows the view from Strawberry Hill (named for the beach strawberry that no longer exists on the hill) looking south across what is now the Inner Sunset. The drifting dunes are nearly completely stabilized by native vegetation. The hill at left is Mount Parnassus (now Mount Sutro) before Adolph Sutro covered the slopes with trees. In the background, Blue Mountain (renamed Mount Davidson in 1911 for George Davidson) can be seen. Look closely at the mountain's profile and the large rock formation called "the spine" can be seen, which is now concealed by Sutro's trees. A steam train ran from Haight Street to Ocean Beach along H Street, now Lincoln Way; the tracks can be seen adjacent to the park.

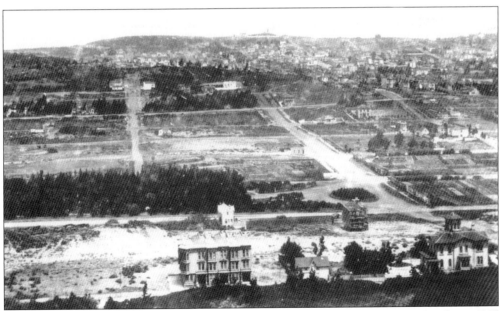

Drifting sand is being covered by Victorian homes of the Haight Ashbury District in this c. 1885 image, taken from Buena Vista Hill and looking north. The oldest planted trees in Golden Gate Park can be seen in the Panhandle with Calvary Cemetery in the background. The early name for this dune-covered valley was "Pope Valley."

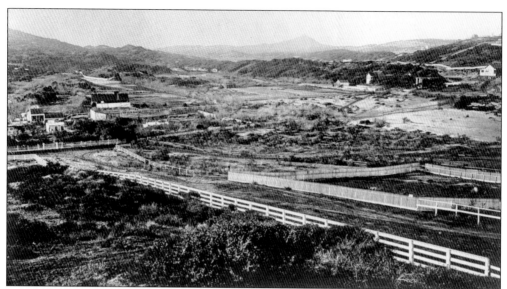

Carleton Watkins placed his camera on the serpentine rock where the U.S. Mint was constructed in 1932 to take this *c.* 1858, northwest-facing photograph of Sans Souci Valley ("care free" in French). The valley that is now the Duboce Triangle and the Lower Haight was the easiest access between Mission Dolores and the Presidio. Since Sans Souci Valley was below steep Buena Vista Hill, water flooded the valley during the rainy season. The sand dunes that had drifted from the ocean are covered with impenetrable dune vegetation, along with coast live oak and arroyo willow (*Salix lasiolepis*). Sans Souci Lake is barely visible in this photograph, but Lone Mountain (now part of the University of San Francisco) is prominent in the background. (The original photograph is at California State Library.)

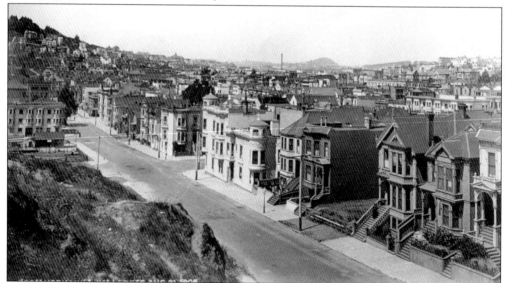

A 1905 photograph by Charles Turrill, taken from the same location as the image above, shows a radically changed landscape. San Francisco's natural heritage has now been replaced with the city's architectural heritage. Hermann Street is the one going left to right, and Lone Mountain can still be seen in the background. The San Francisco College for Women would be constructed on its summit in 1932. (Marilyn Blaisdell Collection.)

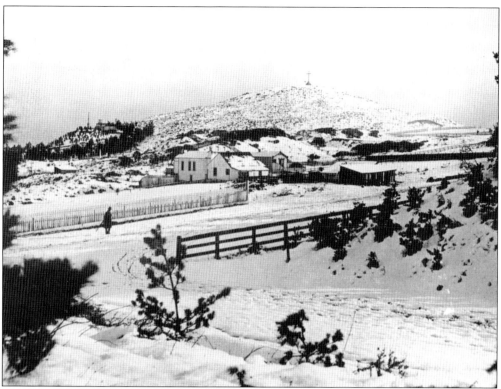

Charles Turrill photographed Lone Mountain after the largest recorded snowfall in San Francisco history on February 6, 1887. Seven inches of snow fell west of Divisadero Street. Archbishop Alemany's cross can be seen on the summit.

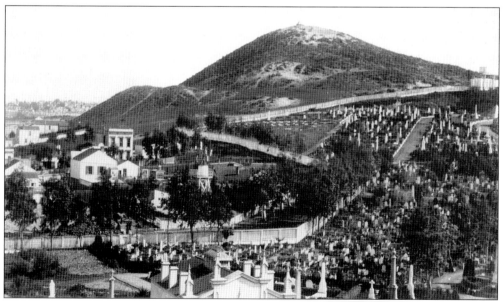

Lone Mountain and Odd Fellows Cemetery (as seen from the roof of the newly completed Columbarium in 1899), shows dense dune vegetation covering the slopes.

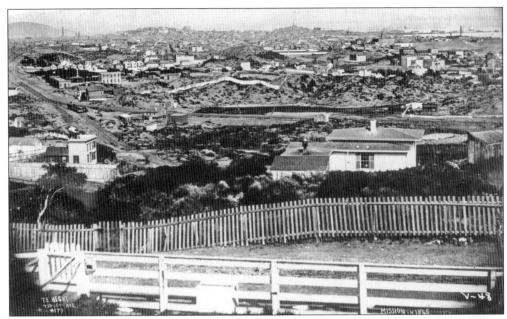

Looking toward Market and Valencia in this 1868 photograph from the site of the Protestant Orphan Asylum property (now the UC Extension site), large sand hills can be seen. Eventually these would be leveled as the city expanded into the Mission District.

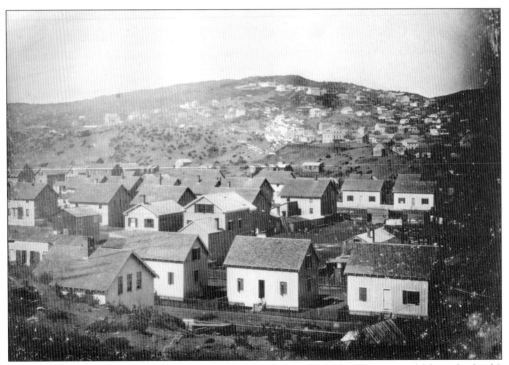

An 1851 photograph looking across Happy Valley (where Market Street would later be built) shows the landscape north to Nob Hill. Dunes dominate the landscape.

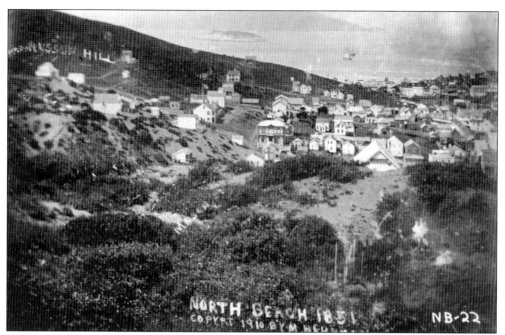

Looking north from Nob Hill, this 1851 photograph shows both drifting and stabilized dunes on Russian Hill. Alcatraz and Angel Island are in the background.

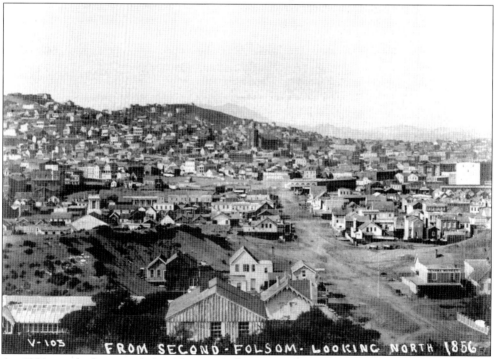

An 1856 view looking north from Rincon Hill at Second and Folsom Streets shows what today would be a wall of high-rise towers. Again sand hills dominate the cityscape. Note the private conservatory at left. The tallest building in the background is St. Mary's Church at Dupont (now Grant) Avenue and California Street.

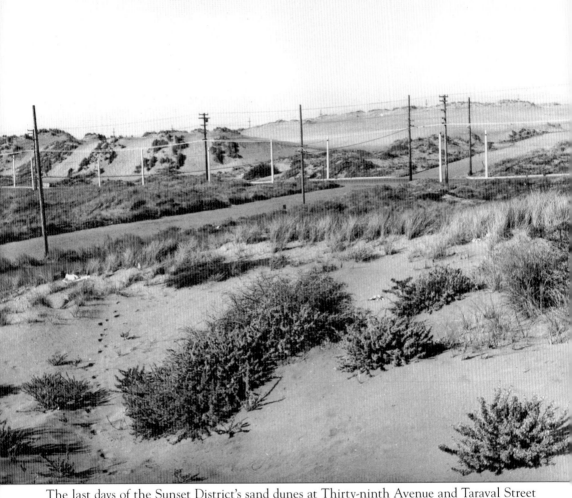

The last days of the Sunset District's sand dunes at Thirty-ninth Avenue and Taraval Street are depicted in 1939.

Two

COASTAL PRAIRIES
AND WILDFLOWERS

In the 1890s the open country everywhere around San Francisco was a beautiful wild flower garden in the spring. In the region near Lake Merced the wildflowers were so thick that it was impossible to avoid stepping on them.

—Alice Eastwood, Curator of Collections, Academy of Science, 1940s

Prairies or grasslands in San Francisco and throughout California evolved with the grazing animals that depended on native grasses. Elk, deer, and rabbit ate purple needle grass (*Nassela pulchra*), California fescue, and other species and then would spread the seeds. With the arrival of the Spanish, domestic animals such as cattle, horses, and goats were introduced and the coastal prairies were overgrazed. Up until the discovery of gold, the cattle produced on large ranchos supported the California economy. Tallow, hides, and dried meat were the main exports of pre-American California.

The importation of European grass to feed cattle stimulated the spread of nonnative annual grasses that out-competed the native grasslands. Exotic plants arrived as seeds in the ballasts of ships or were planted in gardens because they reminded settlers of home. Inevitably the garden plants escaped into the prairies and wildflower fields. Native plants are prevented from becoming weedy as long as they are kept in check by their natural predators (microorganisms, insects, birds, mammals and so forth) that eat all or part of the plant. With no natural controls, the exotic plants spread as weeds. The predators that controlled the nonnative or exotic plants were, unfortunately, not in California. Native plants also became weedy when their natural predators were removed from the food chain. Without elk and deer, native blackberry and poison oak became weedy and displaced the diversity of a prairie or scrub community.

The coastal prairies of San Francisco supported different plants and animals, depending on the bedrock. Serpentine bedrock ranges diagonally across the center of San Francisco from the Presidio across the Richmond District to "Clinton's Mound" (where the U.S. Mint is at Duboce and Market) to Potrero Hill and Hunter's Point. Serpentine grasslands once common in California are now rare. Serpentine, the official mineral of the state of California, is toxic to many nonnative plants. Therefore, weeds have a tougher time establishing themselves in the

serpentine grasslands. The Presidio had large tracts of serpentine grasslands, but tree planting, overgrazing, and development destroyed most of it. Still some fine remaining Serpentine grassland is in the Presidio below Inspiration Point near the Arguello entrance. Extensive renovation has been done to restore the grassland there.

San Francisco also has its own unique coastal scrub communities. Characterized by plants like coyote bush, monkey flower, California sagebrush (*Artemesia californica*), poison oak, coffeeberry (*Rhamus californica*), and toyon (*Heteromeles arbutifolia*), scrub communities offer shelter for nesting birds and a diversity of mammals, reptiles and insects. The native people regularly burned scrub communities to prevent the dense foliage from displacing the coastal grasslands that supplied edible bulb plants. Fire also forced the wildlife to come out into the open where they could be easily hunted.

Native Ohlone people supplied all their needs through gathering or hunting in the natural landscape. Seeds, bulbs, nuts, fruits, and animals were used for food, medicine, and spiritual necessities; agriculture was not needed for sustenance. Similar to the way that invasive, non-native plants destroyed native plant communities because there were no natural controls, the indigenous people of the Bay Area had no immunity to exotic diseases, and most perished as a result.

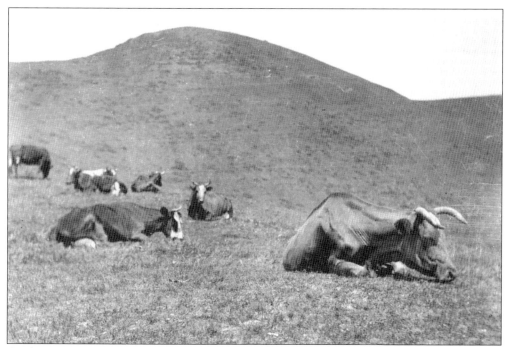

Cattle rest on Twin Peaks after a meal of tasty native grasses and wildflowers. Noe Peak (south peak) is in the background in this c. 1903 image.

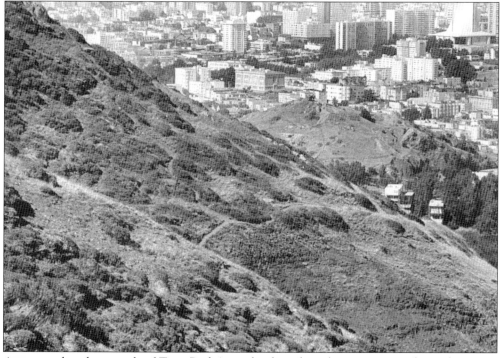

A present-day photograph of Twin Peaks' grasslands and scrub communities shows the native coyote bush, sagebrush, and monkey flower. In the background is Corona Heights, predominantly a grassland community. (Greg Gaar photograph.)

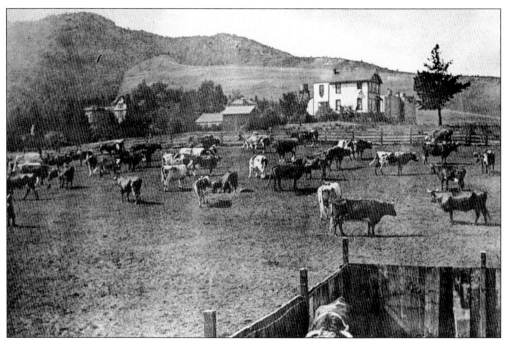

In this 1894 photograph of the Lange Dairy, taken from the present site of Cole and Carl Streets, a large herd of cattle is overgrazing the prairies looking southwest toward Mount Parnassus (now Mount Sutro). A bullpen and bull are visible at lower right.

The serpentine grasslands of the Presidio were photographed c. 1888, looking toward the Golden Gate near the Presidio Avenue gate. Straight rows of eucalyptus trees, planted by Major Jones, will eventually grow to displace the grasslands.

Cha's Bailey. L.A.

A 1908 photograph of Inspiration Point in the Presidio, taken near the Arguello entrance, shows the extensive serpentine grasslands and spectacular view. The steep, rolling hills are the watershed of the Tennessee Hollow riparian corridor in the valley, which may one day be daylighted and restored. By the 1980s, this same view had been replaced by a dense wall of nonnative trees and the rare grasslands were nearly gone. The National Park Service has now restored some the view and much of the serpentine grasslands. Most of San Francisco's remaining coastal prairies grow from a thin layer of soil atop radiolarian chert bedrock. Twin Peaks, Mount Davidson, Glen Canyon, McLaren Park, and Bayview Hill all contain fine examples of native plants growing atop chert bedrock. The native grasslands have incredible displays of wildflowers in the spring and early summer. The greatest threats to these sites are weeds and erosion. When trampling, erosion, or even burrowing animals disturbs the soil, the native plants are damaged or cleared away. Then the most aggressive plants (always invasive and nonnative plants) establish themselves. The most aggressive species come from parts of the world that have similar climates as San Francisco and the Bay Area. Some of the worst culprits include Oxalis (Bermuda buttercup/sour grass), Erharta erecta grass, sheep sorrel and Cape ivy from South Africa, French broom, Himalayan blackberry, fennel (and many annual grasses from the Mediterranean), Tasmanian bluegum (one of 300 species of eucalyptus) from Australia, and pampas grass from Argentina. (Greg Gaar collection.)

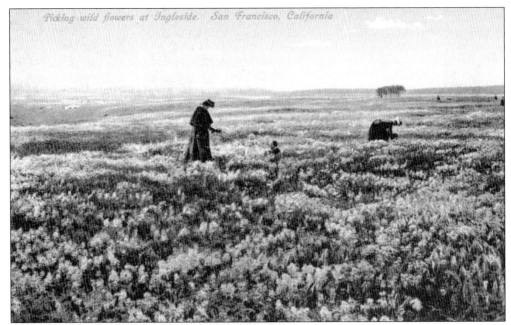

A postcard shows mother and daughter picking wildflowers in the Ingleside District around 1905. This area would be near Stonestown and San Francisco State today. In the words of James Roof, founder of the Tilden Park Botanical Garden, "As the years pass, people will forget that no concentrated natural flower garden in California matched that of the City of San Francisco." (Greg Gaar collection.)

A 1995 photograph shows the annual wildflower Farewell-to-Spring (*Clarkia rubicunda*) covering the northwest side of Bayview Hill. Clarkia is reddish-pink in color and blooms in late spring and was first recorded during the Lewis and Clark expedition. (Greg Gaar photograph.)

McLaren Park grassland displays Johnny Jump-ups (*Viola pedunculata*), which is the larval food plant for the Calliope Silverspot Butterfly, a federally endangered species. This butterfly's main habitat is four miles to the south of McLaren Park on San Bruno Mountain. Intense residential development is rapidly closing off the wildlife corridors, forcing butterflies and even gray foxes to move from San Bruno Mountain to McLaren Park. In the background of this image is Bayview Hill.

Nutka, or Pacific reed grass (*Calamagrostis nutkaensis*), is pictured growing on the north side of the north peak (Eureka Peak) of Twin Peaks. San Francisco Conservation Corps is constructing a stairway to provide access and to protect the habitat. This native grass grows on the north side of San Francisco's three tallest hills (Mount Davidson, Twin Peaks, and Mount Sutro). Nutka reed grass communities are rare.

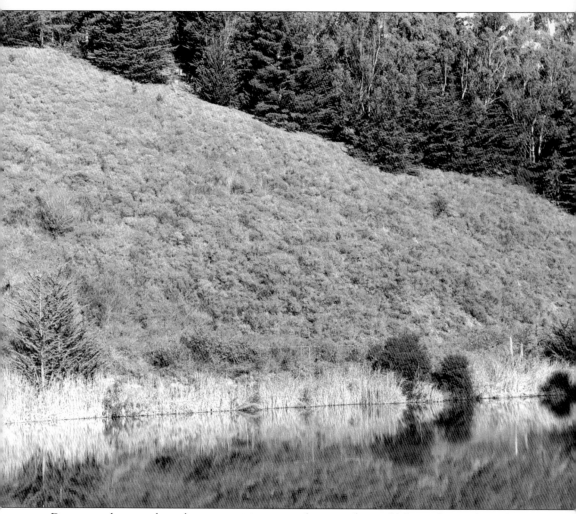

Dense north coastal scrub communities cover the west slope of Mount Sutro above Laguna Honda Reservoir today. This 20-acre slope is one of the best remnants of San Francisco's original landscape. In the spring, birds, butterflies, and spiders are busy finding partners and mating. The slope survives because this is the only place where Adolph Sutro did not plant pine, cypress, and eucalyptus trees. The San Francisco Water Department (SFWD) owns the site, which is a leftover arrangement from the old days when the Spring Valley Water Community used Lake Honda for drinking water. In 2003, the SFWD rented 500 goats to defoliate the rare coastal scrub community, neglecting to go through a public process or to contact the California Native Plant Society or the general public. Fortunately, activists contacted the city attorney's office, and the goats were eventually removed. (Greg Gaar photograph.)

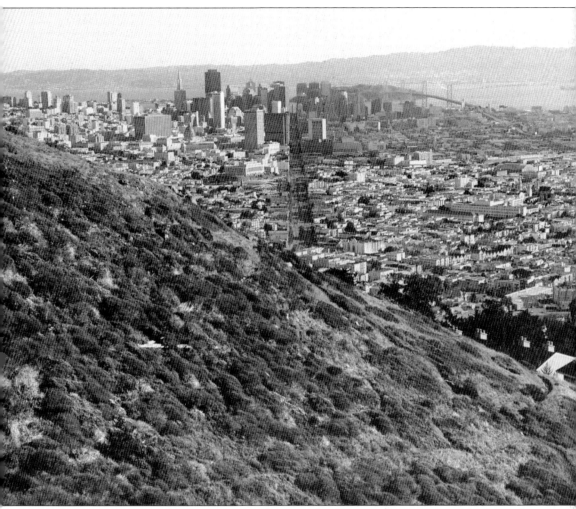

Another large coastal scrub community, on the east side of Twin Peaks, is managed by the city's Natural Areas Program. Every day, thousands of tourists and residents drive to the Christmas Tree Point parking lot to view the dense, human cityscape and ignore the rare, ancient remnant of San Francisco's original landscape. Unfortunately, people also seem to treat the natural area with disdain, as copious amounts of trash are tossed here from the parking lot, contaminating this rare open space. (Greg Gaar photograph.)

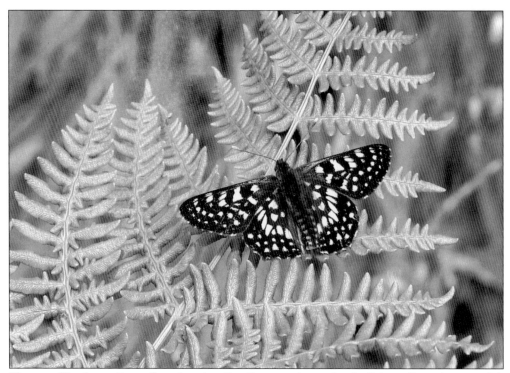

The rare Checkspot Butterfly is found in San Francisco's grasslands. (Margo Bors photograph.)

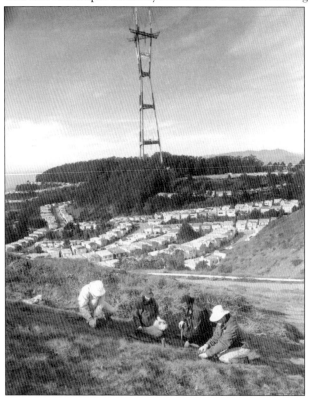

The city's Natural Areas Program and volunteers plant *Lupinus albifrons* in the grasslands of Twin Peaks. This lupine is the prime larval food plant of the Mission Blue butterfly, a federally listed endangered species that still survives on Twin Peaks. Sutro Tower is in the background. (Greg Gaar photograph.)

Three

LAKES AND CREEKS

Into this landscape that was more water than dry land, the coast people came . . ."

—Nancy Olmstead, *Vanished Waters: A History of San Francisco's Mission Bay*

The original settlers of San Francisco (née Yerba Buena) started ranches, farms, and dairies because fresh water was available at a lake or creek. Today the main commercial streets in the neighborhoods are situated where the water was accessible for roadhouses, stables, bars, hotels, and restaurants. Nonetheless, all but four of San Francisco's natural lakes have been filled and paved over.

As for the city's once-numerous creeks and their diverse riparian habitats, all but a portion of Islais Creek and Lobos Creek have been eliminated. Hayes Creek, Yosemite Creek, Mission Creek, Dolores Creek, Eire Creek, Precita Creek, Trocadero Creek, and others have been filled in, paved over, or placed into storm drains and sewers. Only in recent times has a movement started to preserve and restore creeks and watersheds. The National Park Service in the Presidio, for example, is going through a public process to "daylight" the Tennessee Hollow creek system from Inspiration Point to the newly created tidal marsh at Crissy Field.

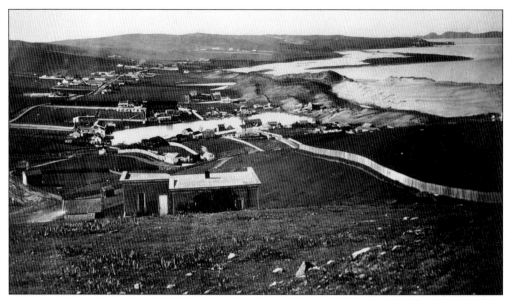

Washerwoman's Lagoon (Laguna Pequeña, or "small lake") was situated in the Cow Hollow district on what is now Lombard, Gough, Filbert, and Octavia Streets. It was initially used as drinking water for wildlife, and then for people and livestock, and finally for laundry water. By 1882, the lake was heavily polluted, and Cholera cases were blamed on its filthy water (Mayor Burr's son died from cholera) and it was thus filled in. Photographer Carleton Watkins took this photograph c. 1856 looking north to Washerwoman's Lagoon with the Presidio in the background, a quarter century before Major Jones began planting trees on the military reservation's serpentine grasslands. The original dunes on future Crissy Field and Strawberry Island can be seen adjacent to the shore.

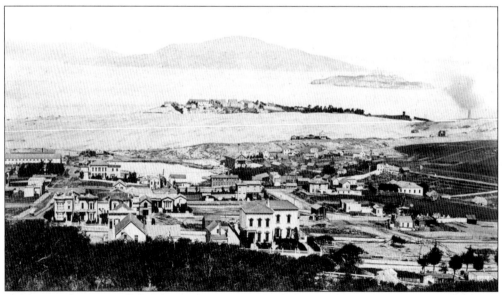

Here is another view of Washerwoman's Lagoon from Pacific Heights in 1881, a year before it was filled. Note the native coast live oaks in the foreground, and look closely for the Octagon House that still stands at Union and Gough Streets. Across the drifting dunes is Fort Mason on Black Point.

Laguna Seca (dry lake), pictured here in 1894, was situated in the valley at Cole and Parnassus. The lake collected runoff water from the steep San Miguel Hills of Mount Parnassus (now Mount Sutro), Twin Peaks, and Mount Olympus. William Ferdinand Lange developed the Lange Dairy next to the lake in 1870. By 1894, civilization had encroached on the diary and Lange formed the Lange Land Company. The seven-acre dairy was subdivided and Laguna Seca was covered to make way for Cole Street and housing. (Greg Gaar collection.)

The same valley is shown here in 1908, illustrating how rapidly Cole Valley was developed after the earthquake. Laguna Seca is completely gone. Golden Gate Park is in the background.

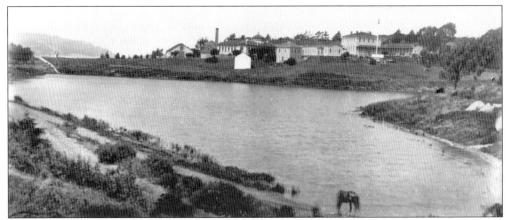

Here is Mountain Lake in the Presidio, photographed in 1899 and looking west to the Marine Hospital (later the Public Health Hospital). You can see sand and lupine adjacent to the lake and some planted eucalyptus in the background. Juan Bautista de Anza camped here in 1776 when his expedition was searching for good locations for a mission and a presidio. Wrote Father Font in his diary at the time, "Then we entered lands somewhat broken and sandy, with plentiful grass and brushy growth, without any large trees. Then, going around the sand dunes of the beach, which we kept at our left and whose vicinity we saw a good-sized lake of fresh water, we came to the lake where we halted." The National Park Service recently removed 100 eucalyptus trees from the lake, and restored the shoreline with 4,000 plants native to riparian and oak woodland communities. The restoration project was honored with an award from San Francisco Beautiful.

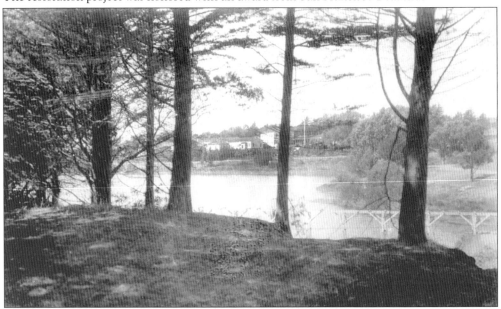

By the 1940s, when this photograph was taken, the heavily used roadway taking traffic to the Golden Gate Bridge and the Marina had a major impact on Mountain Lake. The damage continues to the present. Debris was dumped into the lake during the road's construction, causing it to lose half of its original depth and much of its original size. Runoff from the roadway has also drained numerous toxins into Mountain Lake including lead, oil, and asbestos. Pesticides from the golf course have also flowed into the lake. The National Park Service has made dredging plans to remove the contamination.

In 1863, Laguna Honda at Laguna Honda Boulevard and Clarendon Avenue was being converted from a lake into a reservoir. Many native-plant communities meet at Laguna Honda Canyon. A dense north coastal scrub community is growing on the western slopes of Mount Parnassus (now Mount Sutro). Heavily grazed grassland or coastal prairie is in the center of the photograph on the lower western slopes of Twin Peaks (and the present location of Laguna Honda Hospital). In the background is the tallest hill in San Francisco, Mount Davidson, which still retains a huckleberry reed grass prairie. In the deepest part of canyon is the riparian habitat. A rapidly flowing creek carved this canyon and as the sand dunes advanced inland, the creek was naturally dammed by the dunes and two lakes were formed: Laguna Honda and the "waste pond" at Seventh and Lawton Streets. An aquifer still flows underground and makes its way into Golden Gate Park, along the route of the original creek and into Golden Gate Park's Strybing Arboretum, where the water is pumped to the top of Strawberry Hill and used for irrigating the park. Sand dunes that had drifted three miles inland from the ocean can be seen at far right.

This present-day photograph was taken from the same location as the 1863 photograph, showing the major changes to the flora. Dense nonnative trees have replaced what was a diverse mixture of grassland, scrub, oaks, and dunes.

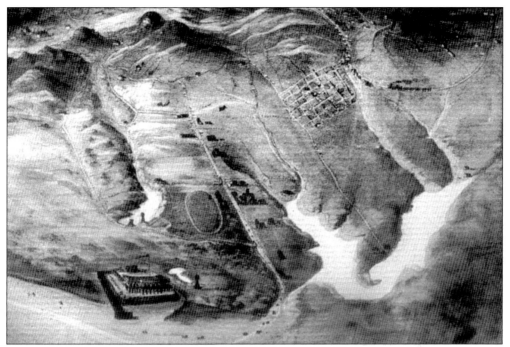

This 1868 painting depicts a bird's-eye view of Pine Lake and Lake Merced in the western part of the city. The source of water for both lakes is the underground aquifer in the western part of San Francisco.

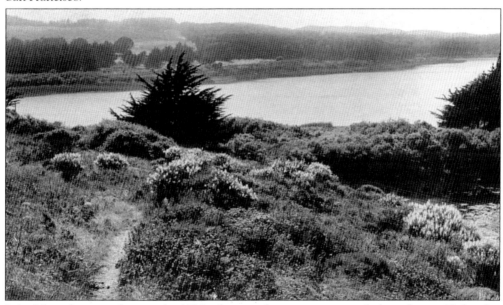

Lake Merced appears here in the 1930s, showing dune vegetation and planted trees. Today this lake remains an important natural resource for human recreation and wildlife. The Friends of Lake Merced and the Natural Areas Program are involved in habitat restoration on the shoreline and a master plan for the lake and adjacent lands. Lake Merced, like Pine Lake, has been impacted by reduced water levels due to past uncontrolled exploitation of the aquifer. It was also contaminated by lead shot (no longer allowed) from the adjacent firing range.

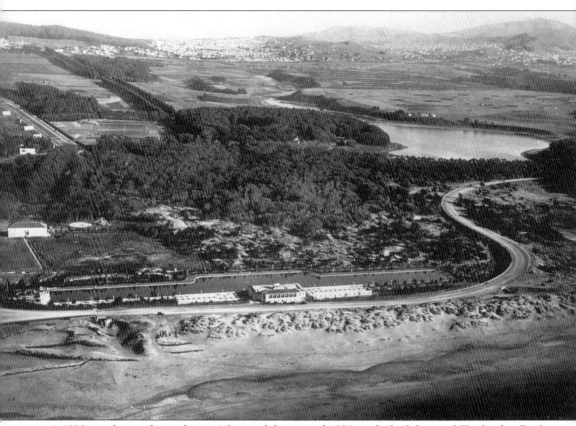

A 1930 aerial view shows the city's largest lake around 1930, with the lake-sized Fleishacker Pool in the foreground. The saltwater pool was 1,000 feet long from north to south, making it the longest swimming pool in the world.

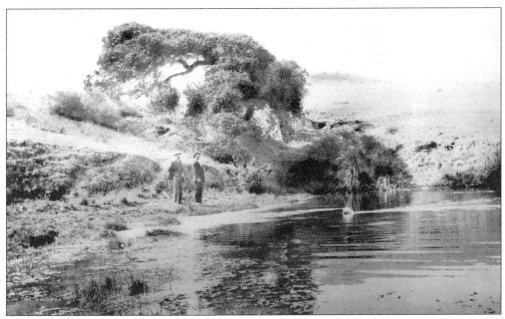

Lake Merced's South Lake in San Mateo County is pictured here as it looked in 1901. Note the sand dunes and large coast live oak tree. (Greg Gaar lantern slide collection.)

A car advertisement photograph, taken in 1924, shows Lake Merced's Impound Lake near Lake Merced Boulevard and Brotherhood Way.

Pine Lake, on the western end of the gully adjacent to Sigmund Stern Grove, has had many names. Originally called Laguna Puerca (Pig Lake) by the Spanish-speaking Californios, it was later called Mud Lake or Dirty Lake. The site was originally a river valley carved by Trocadero Creek. As sea level rose, the dunes came inland and dammed the creek system and formed the lake. In 1847, George Greene and his family, who came to America to escape the "potato famine" in Ireland, settled in the valley and planted crops of potatoes, along with trees to protect the crops from the prevailing winds and drifting dunes. They built roadhouses, including the famous Ocean House and eventually the Trocadero Inn. The Green Family sold their property to Rosalie Stern in 1931, who gave Stern Grove and Pine Lake to the City of San Francisco for a park and a memorial to her husband on June 4, 1932. Today Pine Lake is about half the size seen in this c. 1910 photograph. The underground water (it is connected to the same aquifer that supplies Lake Merced) has been used to irrigate golf courses and cemeteries.

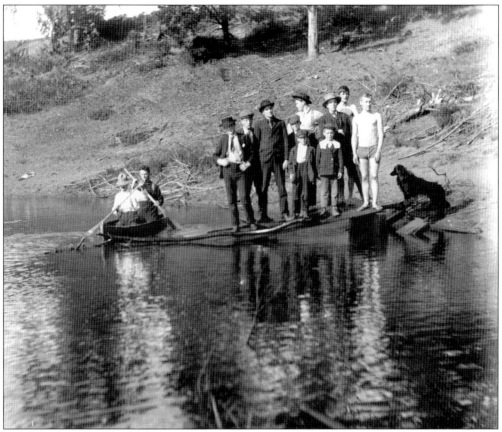

Parkside boys hang out at Pine Lake around 1903.

Kelly's Pond, once located at Euclid and Palm Avenues in Jordan Park, was filled in the 1880s. The lake was a resting spot for migrating waterfowl and was therefore a popular hunting site.

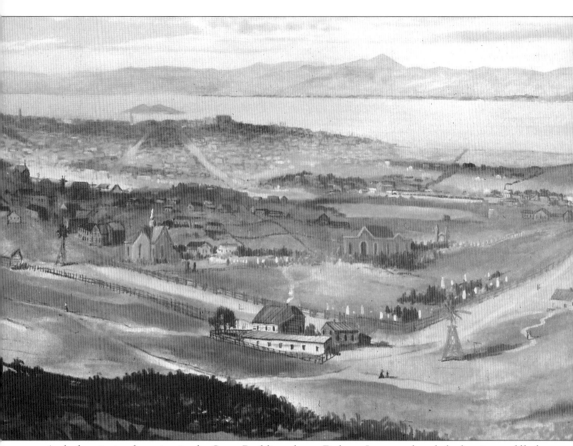

A cloth painting hanging in the State Building shows Dolores Lagoon shortly before it was filled in. In the foreground are the headstones and mausoleums of the two Jewish cemeteries where Dolores Park is today. There are no known photographs of Dolores Lagoon, but the small lake at Eighteenth and Guerrero Streets collected water that rushed down Dolores Creek from Twin Peaks and down Eighteenth Street. The water would overflow down Mission Creek and empty into Mission Bay. Supplies for the original Mission Dolores were transported by boat along mission creeks and unloaded in Dolores Lagoon.

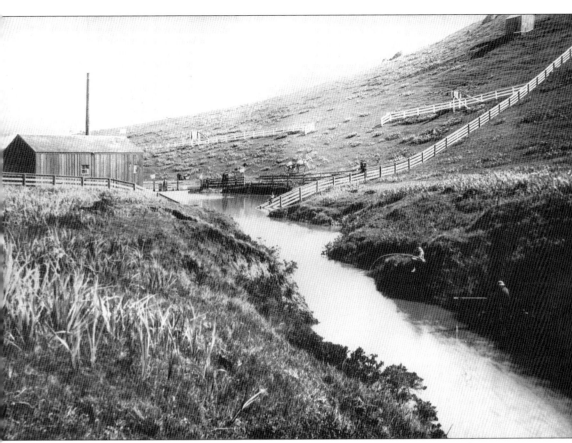

Pictured is Islais Creek in the 1880s, near the present site of the Glen Park Playground Recreation Center. Today this section of the creek is corralled in by a large pipe that takes water under the baseball fields and eventually to San Francisco Bay. For hundreds of thousands of years, Islais Creek and all of San Francisco's tributaries supplied habitat and sustenance for herds of elk, troops of now-extinct California grizzlies, mountain lions, and hundreds of other species of wildlife. Glen Park's beautiful rocky canyon was created by the continual flow of Islais Creek. Notice the native grasses and iris that cover the land next to the creek. O'Shaughnessy Boulevard and dense eucalyptus plantations impact the steep slope today.

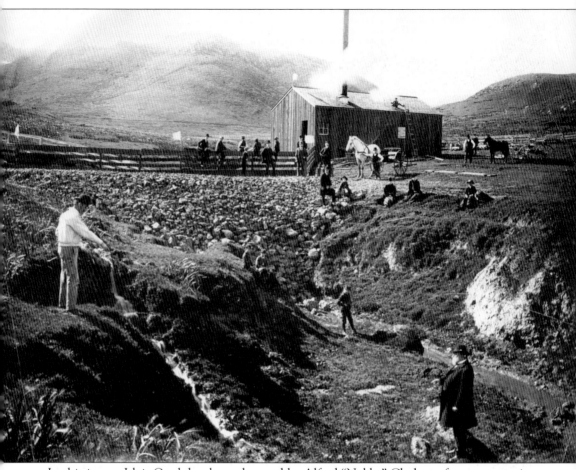

In this image, Islais Creek has been dammed by Alfred "Nobby" Clarke to form a reservoir so water can be pumped to Clarke's Waterworks in Eureka Valley. Clarke constructed the Queen Anne Victorian called Nobby Clarke's Folly, which still stands at Caselli Avenue and Douglass Street. The steep hills in the background, now fragmented by O'Shaughnessy Boulevard, were part of the large watershed for Islais Creek. Before urbanization, Islais Creek was more a river than a creek. Twin Peaks, the three hills of the Diamond Heights (Red Rock, Gold Mine, and Fairmount Hill), and all the land from Mount Davidson to Glen Park absorbed rainwater that flowed down to Islais Creek. There were no asphalt roadways, sewers, and storm drains to stop the natural runoff. Islais Creek, named for the native shrub Islay, is the only true creek surviving on Recreation and Park property. Though most of the creek is confined in an underground storm drain, a half-mile section still runs its original course, aboveground and through Glen Canyon Park. The Natural Areas Program was awarded a grant from the California Coastal Conservancy to restore this remnant of Islais Creek.

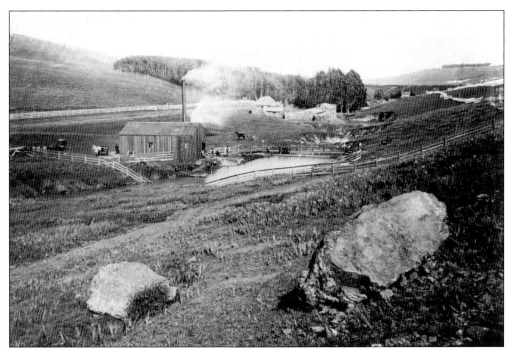

Another view of the same Islais Creek location shows the same pump house as in the two previous photographs. The beautiful valley is blanketed with Douglas iris (naturally toxic to cattle so they don't eat it). In the background is the Gum Tree Ranch, the center of the Glen Park district, where Chenery and Diamond Streets intersect.

Taken from the same location today, this modern view looks east across the Glen Park Playground. Islais Creek is still there, but it flows in a pipe under the recreation field. (Greg Gaar photograph.)

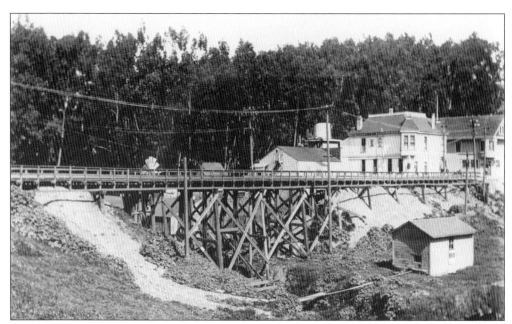

A streetcar trestle was constructed by United Railroads so the city's first electric streetcar could cross Islais Creek. Today this is the intersection of Diamond and Chenery Streets, and nearly all the buildings still stand (Tygers, at far right, is Glen Park's most popular breakfast spot). Behrend Joost, president and owner of both the streetcar company and the Sunnyside Land Company, constructed the San Francisco and San Mateo electric system to attract buyers to the Sunnyside District. He pumped water from Islais Creek for the boilers that generated electricity for the streetcar line. The powerhouse was located at Sunnyside (now Monterey Boulevard), Circular, and Joost Avenues. This image was taken around 1900. (Randolph Brandt Collection.)

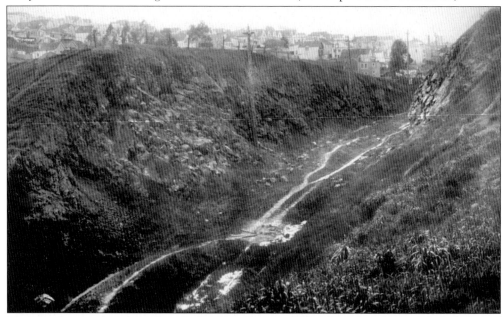

Islais Creek meanders through a small canyon here in 1920. This natural feature was destroyed when Alemany Boulevard was constructed.

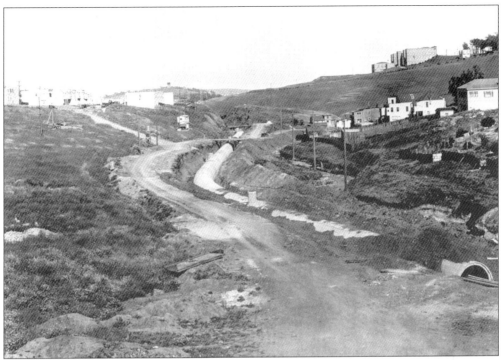

As pictured here in 1928, Islais Creek was forced into a storm drain to allow for the construction of Alemany Boulevard and later the Interstate 280 freeway.

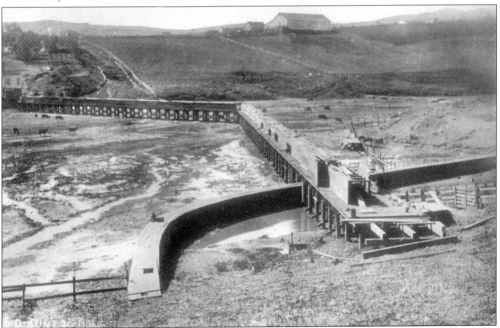

Islais Creek enters San Francisco Bay where the Farmers Market and the freeway interchange for 280 and 101 is today. This 1904 photograph, looking south, shows the freshwater riparian habitat meeting the saltwater tidal marsh. The site must have been an incredibly diverse habitat for fish, crustaceans, and shorebirds.

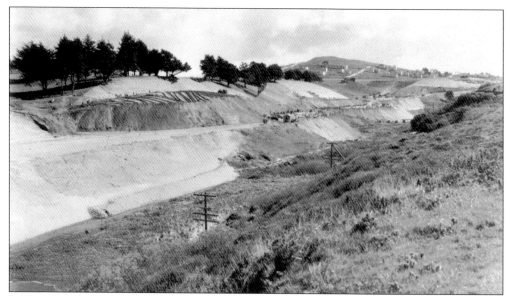

In 1935, hundreds of Works Progress Administration (WPA) employees construct Stanley Drive (now Brotherwood Way) adjacent to another Islais Creek tributary. This riparian corridor, dominated by Arroyo willow trees, supplied water to Lake Merced. Huge sand dunes and Merced Heights are visible in the background.

The same view in 1956 shows the riparian corridor still surviving. Today churches, synagogues, schools, and acres of parking lots have all but obliterated the wetland. A small dune chaparral and some oak woodlands survive on the slope behind the churches. Besides the endangered Raven's manzanita in the Presidio, this is the only other location of manzanita in San Francisco. The shaggy-barked manzanita (*Arctostaphylos tomentosa*) also occurs on Mount Tamalpais and in Monterey County. Some of the schools and churches have taken an active role in managing the slope. Destroying wetlands was an acceptable practice until federal protection was implemented in the 1970s. (Peter Rubtzoff photograph.)

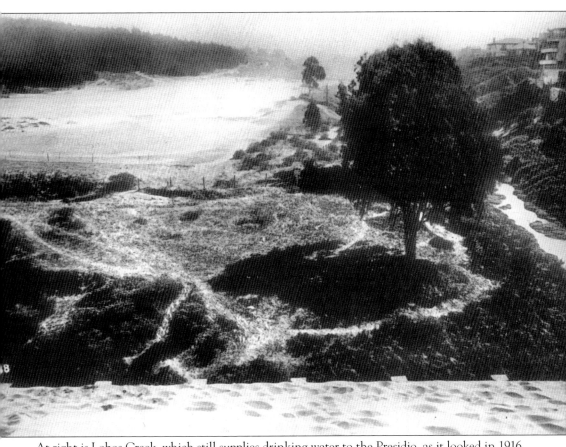

At right is Lobos Creek, which still supplies drinking water to the Presidio, as it looked in 1916. Drifting sand dunes that advanced inland from Baker Beach cover what is called Lobos Creek Valley today. The valley went from sand dunes to a recreation field for military dependents, and back to sand dunes when the National Park Service and volunteers recreated the dune habitat. Lobos Creek Valley was the last location where the Xerces Blue butterfly was sited before it went extinct in the 1950s. Ansel Adams, the great environmental photographer, grew up in the family home that still stands adjacent to Lobos Creek. In the Presidio dunes adjacent to Lobos Creek, young Ansel learned the joy of landscape photography.

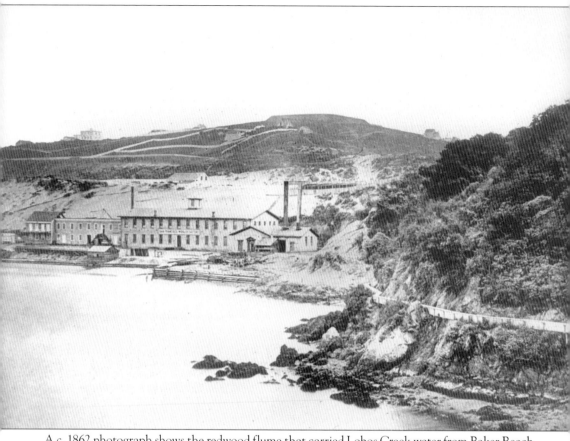

A *c.* 1862 photograph shows the redwood flume that carried Lobos Creek water from Baker Beach to a reservoir on the summit of Russian Hill. The 3.5 mile-long flume is coming around Black Point (Fort Mason) and heading to the pump house where the smokestack is located among the buildings of the Pioneer Woolen Mill (now Ghirardelli Square and Aquatic Park). The water was then pumped to the top of Russian Hill, which is prominent in the background. City residents purchased water from the private water company (the San Francisco Water Department did not exist until 1930). At right is Black Point, the location of today's Fort Mason, which is the only significant surviving remnant of San Francisco's original bay shore.

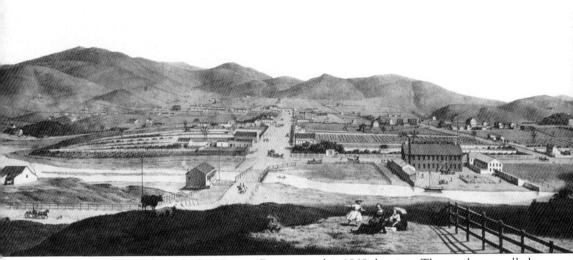

Mission Creek flows through the Mission District in this 1868 drawing. The creek was called *Esterito de los Laureles* ("little estuary of the bay trees") and Estero de la Mision by the Spanish-speaking Californios. The headwaters for Mission Creek were the steep San Miguel Hills including Twin Peaks, Buena Vista Hill, Mount Olympus, and Corona Heights. Portions of it still travel under the Mission District. Dolores Creek, which flowed into Dolores Lagoon, was a tributary of Mission Creek. Remnants of this tributary can still be seen flowing under an old barn between Caselli Avenue and Eighteenth Street.

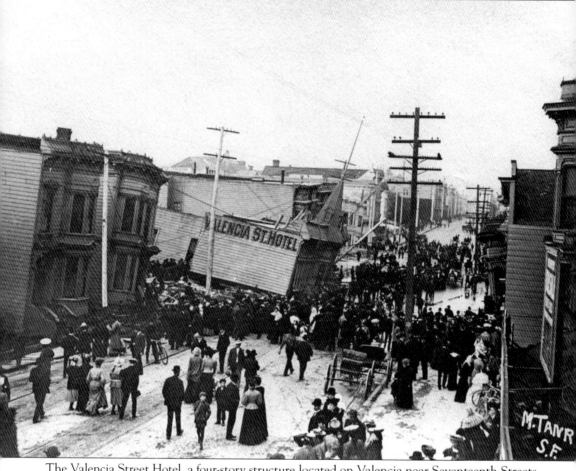

The Valencia Street Hotel, a four-story structure located on Valencia near Seventeenth Streets, was built on top of Mission Creek's riparian corridor. When the 1906 earthquake struck, the top collapsed onto the lower three stories. Water from Mission Creek drowned trapped residents and the fire that swept through the Mission two days later burned anyone not rescued from the debris. An important rule in earthquake country might be, "Don't live on filled land that was originally bay, lakes, or creeks."

Four

TREES

This place afforded much pasturage, sufficient firewood and good water for establishing the fort (presidio). Only timber was lacking as there were no trees on those heights; but not far away were live oaks and other trees. The soldiers chased some deer, but secured not one. We also saw antlers of large stags.

— Father Font's diary from Anza expedition, 1776

The Franciscan Biological Region, ranging from Montara Mountain in Pacifica to just south of Muir Woods in Marin County, lacks dense forests. The tree population itself is sparse, and it is doubtful that it will ever be known how many trees existed throughout San Francisco's natural landscape since the European and eventually American settlers immediately cut down the trees for firewood and building material. Oak trees were an extremely important resource for the native people. Acorns were used as a food staple, oils were used for tanning hides, and dyes used for ornamentation and tattoos. Botanical records from Dr. Menzies of the Vancouver expedition in 1792 show that California buckeye trees (*Aesculus californica*) grew along the "skirts of the Bay and hill Country behind." Since nearly all of the original bayshore has been destroyed and trees cut for firewood, the buckeyes were eliminated. The best survivor is at Twenty-second Street and Pennsylvania Avenue above the Caltrain station, which would have been close to the original bayshore. Arroyo willow thickets lined the former city creeks, along with occasional wax myrtles. California bay trees or laurels were located along Mission Creek in the Mission District (called the creek of the little laurel trees). A large survivor is located behind the old Notre Dame School at Dolores and Sixteenth Street. Coffeeberry (*Rhamnus californica*) and toyon (*Heteromeles arbutifolia*), though classified as shrubs, can grow to the size of a small tree.

Tree-planting projects were common practice in early San Francisco. Fast growing eucalyptus, Monterey pine, and Monterey cypress were planted for windbreaks to protect settlers, crops, and livestock. But the planted trees rapidly changed much of San Francisco's original landscape. In the 1870s, the Greene Family planted thousands of cypress, pine, and eucalyptus adjacent to Pine Lake in what became Sigmund Stern Grove. The Gum Tree Ranch near Chenery and Diamond Streets in Glen Park was named for the dense planting of eucalyptus that sheltered the windy

valley. And to create Golden Gate Park, William Hammond Hall and eventually John McLaren planted pine, cypress, eucalyptus, and Australian tea trees within the native oak woodlands and dune scrub.

Starting in 1883, Major W. A. Jones planted straight rows of eucalyptus, pine, and cypress around the main post and along the ridges of the Presidio. By 1892, 330,000 trees had been planted in the Presidio. By 1902, Jones stated that the trees had been overplanted and according to historian Pete Holloran's article, "Seeing the Trees Through the Forest: Oaks and History on the Presidio," Jones had developed an appreciation for the scenic and natural beauty of the Presidio and recommended removing trees in some areas to plant lupines and other wildflowers. Adolph Sutro created jobs for the unemployed and sponsored Arbor Days by planting tens of thousands of trees over the San Miguel Hills of Mount Sutro, Forest Hill, Edgehill, and Mount Davidson.

The dense tree plantations appear natural and are visually impressive from a distance, but ecologically the impact was nothing short of a disaster. As the saplings grew into large trees, the dense canopy (or overstory) eliminated sunlight to the native grasslands, wildflower fields, scrub, and oak woodlands, which inevitably destroyed the native-plant communities and displaced all of the resident animals, birds, and insects that depended on them for food and habitat. The moisture dripping off the trees from fog and rain causes the understory to become extremely wet, promoting the growth of weedy English ivy and cape ivy. These aggressive vines inevitably climbed and killed the trees and blanketed the understory so thickly that seeds from the trees couldn't reach the soil to germinate. The highly evolved ecosystem that flourished for a million years was replaced by a "biological wasteland."

Compare the remnant tree plantations on Mount Davidson, Mount Sutro, or in the Presidio with the native forests of California's redwoods, the Amazon rainforest, or the Australian eucalyptus forests. The native forests have survived for a million years because the ecology of the forests—all of the plants and animals—maintain a balance through adaptation and natural checks and balances. No plant or animal is able to destroy the entire habitat. When human beings plant trees in an intact treeless ecosystem or plant nonnative trees in a native oak woodland, the entire native ecosystem is rapidly altered and inevitably destroyed. Most plants and animals cannot adapt to the rapid change in loss of sunlight, increased moisture, falling debris from taller trees, and change of chemical composition.

Now that the nonnative tree plantations are nearly 150 years old, some wildlife have adapted to the exotic conditions. Hawks and great-horned owls nest in the trees, but these predators need to find prey in the open grassland and scrub communities. Skunks, raccoons, and opossum utilize the dense understory for dens to raise their young.

54

With the familiar profile of Mount Tamalpias in the background, snowy egrets nest on buckeye trees on North Marin Island in San Francisco Bay.

A 100-year-old planted buckeye grows in a front garden of an 1870s cottage at Willard North and McAllister Streets, one block north of the former Jefferson Airplane mansion.

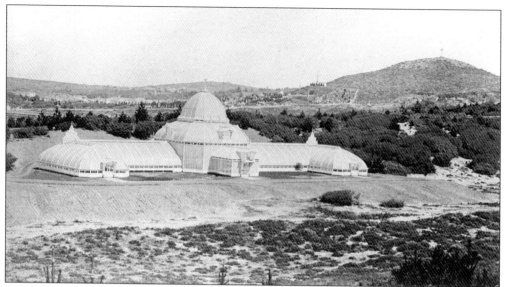

Here is the Conservatory of Flowers in Golden Gate Park as it looked in 1880. Behind the Conservatory is the Oak Woodland, which still survives today. The best stand of oaks is in Coon Hollow, named for Mayor Coon, adjacent to Fulton Street between Arguello Boulevard and Fourth Avenue. Monterey pine trees, from Monterey or southern San Mateo counties, were planted amongst the oaks. However, the taller growing pines, eucalyptus, and cypress are detrimental to the oaks because they take away sunshine and drop much debris. In the background is Lone Mountain, with Archbishop Alemany's cross on the summit; the white specks are headstones for Odd Fellows Cemetery.

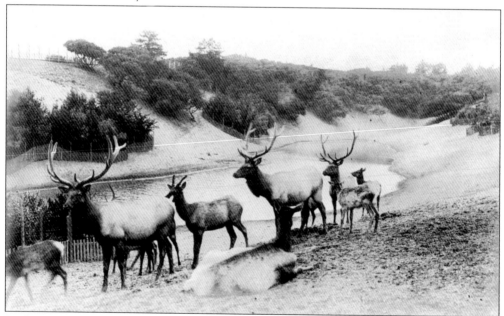

Looking west across the Deer Glen in 1899, now the National AIDS Grove, this photograph shows a herd of elk, an interdune pond and a small native oak woodland in the background. The oaks are indigenous to this site. Recently, Sudden Oak Death Syndrome was discovered in some of the oaks in the AIDS Grove.

56

Sutro's dense tree plantation is quite prominent in this 1910 image from Merced Heights looking north to Mount Davidson. The abandoned Ingleside Racetrack is visible at left, with Ocean Avenue in the valley.

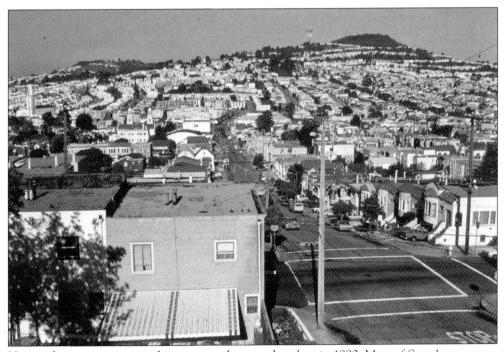

Here is the same view as in the previous photograph, taken in 1990. Most of Sutro's trees were clear-cut for construction of residential neighborhoods. Mount Davidson Park is the last large open space at the summit. (Greg Gaar photograph.)

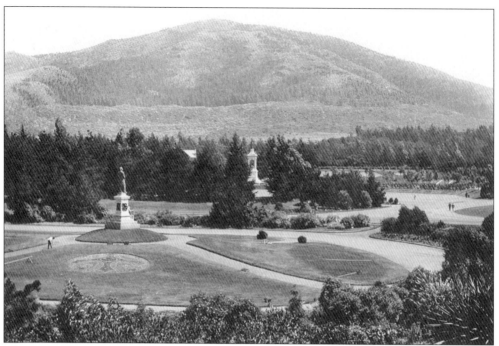

This *c.* 1899 image from Conservatory Valley in Golden Gate Park shows thousands of tree saplings on Mount Sutro. The pine, cypress, and eucalyptus trees were planted in 1886 by Adolph Sutro.

In this present-day photograph inside of Mount Sutro's tree plantation, only two plants (English ivy and eucalyptus) are visible where hundreds of species once thrived. The ivy is climbing and killing the trees in this example of a "biological wasteland."

Five

THE BAYSHORE

One thing about the cover of Yerba Buena was the great number of good-sized fish that swam close in shore and were stranded by the out-going tide. These were the natural food of all sorts of predacious animals. I often used to sit on the veranda of my father's house and watch bears, wolves, and coyotes quarreling over their prey along what is now Montgomery Street. These wild animals were perfectly harmless, only it was not wise to have too much fun with an old bear with cubs.

—Steve Richardson (1831–1924), from *San Francisco Memoirs: 1835–1851*

All of San Francisco's original bayshore except for Fort Mason has been altered. The rich tidal marshes, bays, and estuaries have been completely eliminated for development. San Francisco Bay has lost over 80 percent of its tidal marshes and a third of its total square miles. After two centuries of destruction, restoring tidal marshes and the rejuvenating health of San Francisco Bay has finally become a popular trend.

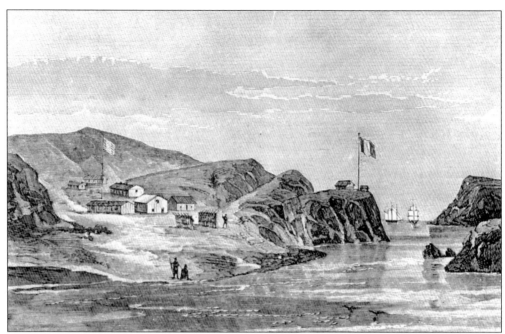

Before construction of Fort Point, a smaller fort stood on the cliff above the Golden Gate. This sketch shows the flag of Mexico flying above the fort.

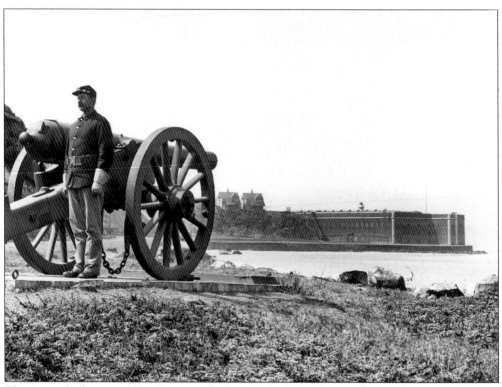

This image looks toward Fort Point in the late 1880s. (Greg Gaar collection.)

This 1880s image of the Presidio's shoreline shows the freshwater marsh, as seen from the serpentine cliffs above the bay.

Here the Presidio's tidal marsh has been filled to construct an airfield for the 1915 Panama Pacific International Exposition. The Tower of Jewels (under construction in the background) was the centerpiece for the fair. All of San Francisco's original tidal marshes were destroyed, but Crissy Field was recently reworked into a semblance of its original natural state after much cleanup.

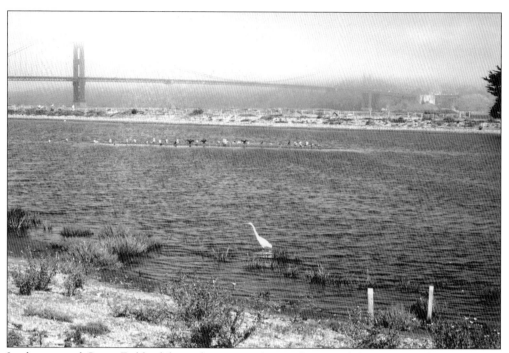

In the restored Crissy Field tidal marsh, an egret forages for a meal. (Greg Gaar photograph.)

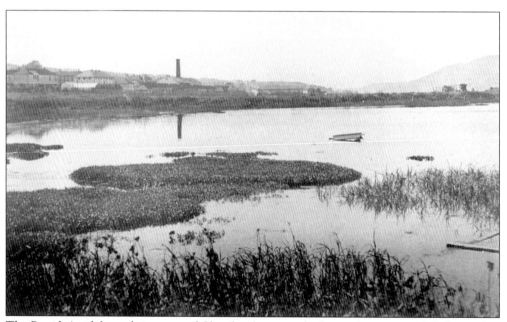

The Presidio's tidal marsh is a natural filter for cleansing the bay and creating rich habitats that supply food and resting areas for resident and migrating shorebirds. Tidal marshes at high tide bring mollusks and fish inland, and at low tides egrets, herons, plovers, and other shorebirds forage for food.

This is a modern view of Black Point (Fort Mason) with the *Jeremiah O'Brien* liberty ship in the background. This is the only true remnant of San Francisco's original bayshore. All the original bayshore except for Black Point has been developed or cut away for bay fill. (Greg Gaar photograph.)

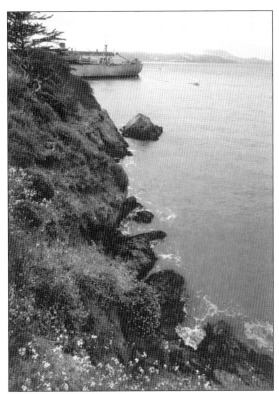

Pictured here is the view from Telegraph Hill to Tonquin Point, named for the *USS Tonquin* that went aground at that location. The ship was named for the Gulf of Tonquin in French-Indo China (Vietnam). The point was nicknamed "White Point" since it was covered with white sand. Black Point (called Point San Jose by the Spanish explorers), west of White Point, is the site of Fort Mason. Tonquin Point was leveled for bay fill for the construction of Fisherman's Wharf.

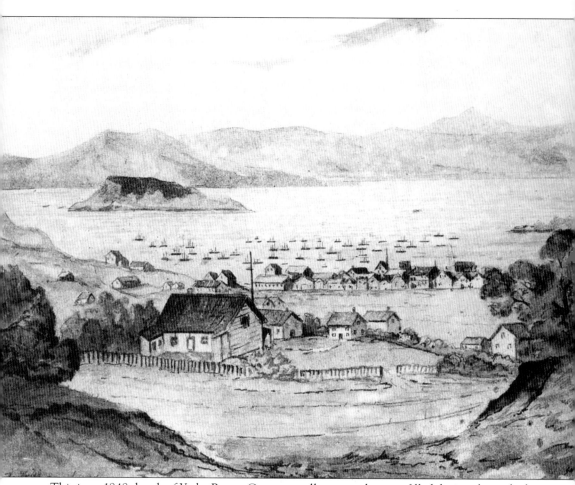

This is an 1848 sketch of Yerba Buena Cove, a small estuary that was filled during the early days of San Francisco. It was named for the native plant, yerba buena, which covered the steep slopes above the cove. Yerba buena still grows in many natural areas of San Francisco, such as Twin Peaks, Bayview Hill, McLaren Park, Laguna Honda, and the Presidio. Today the financial district covers Yerba Buena Cove.

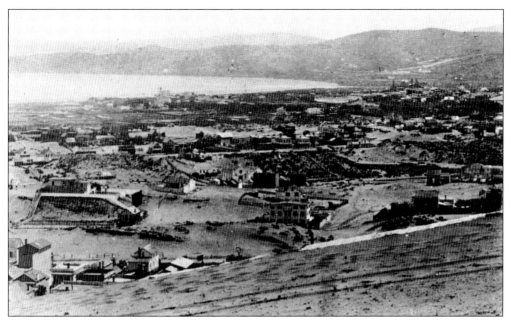

An 1865 photograph looks toward Mission Bay from Cathedral Hill looking across the sand hills of South of Market and the Mission. Note that Potrero Hill is a large peninsula sticking out into the bay. (Charles Weed photograph, from stereoview.)

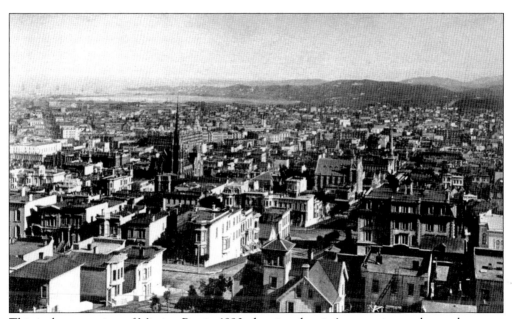

This is the same view of Mission Bay in 1890, showing the city's expansion to the south.

Islais Bay (at low tide looking south in 1916) had railroad tracks for commuter trains before it was filled in completely as it is today. In the background is Mount St. Joseph, where trains go through the tunnel at Palou and Phelps.

A modern view of the same area as in the previous photograph shows that Islais Bay is gone today.

The controversial Hunters Point PG&E power plant is shown from Heron's Head Park (shaped in the form of a heron's head). The park is a former landfill site that is now a shoreline park in India Basin. Over years of tidal action, a rich saltwater tidal marsh was created along the shore of what was then Pier 98. Over 100 species of shorebirds forage for food along the shoreline. The 24-acre park is tended by Literacy for Environmental Justice and kids from the Bayview-Hunters Point District. The strange-looking creature is a bat ray that was speared by a local fisherman. (Greg Gaar photograph.)

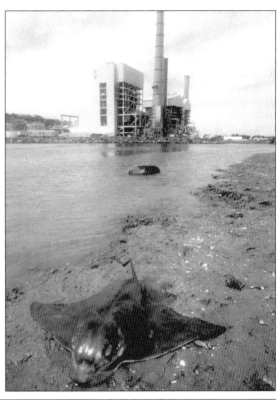

This 1933 image shows the large bay south of Hunters Point, with Bayview Hill in the background. Today most of this bay has been filled in and is called Yosemite Channel. Note the tidal marsh along the shoreline.

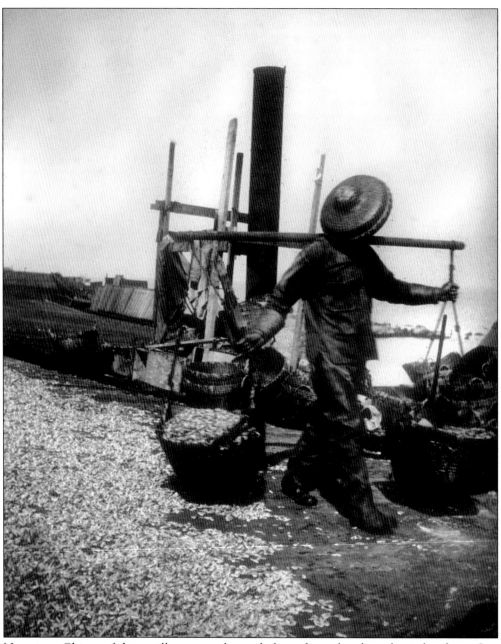

Numerous Chinese fishing villages were located along the isolated southeast bayshore. San Franciscans would purchase shrimp, clam, crab, and fish taken from the bay. Today the shoreline is contaminated with toxins left by ship-repair facilities and the U.S. Navy.

Six

RESTORING
SAN FRANCISCO'S
NATURAL AREAS

Take anything from us—our cable cars, our bridges, even our Bay—But leave us our hills.

—Herb Caen, *The Hills of San Francisco*, 1959

The San Francisco Recreation and Park Department's Natural Areas Program (NAP), with one supervisor and seven gardeners, manages 30 natural areas covering over 1,000 acres. NAP depends on and encourages volunteers to help preserve these important remnants of San Francisco's natural heritage. NAP has successfully applied for and been awarded numerous grants to help sustain the program's goal of public education and habitat restoration. Nearly half of the annual budget for the program comes from grants, reducing the demand for public funds.

Habitat Restoration is based on strict scientific guidelines and achieved with hard physical labor. Battling and controlling weeds, propagating plants, and planting and maintaining restored habitat is a workout. Though much of the labor is accomplished by staff and volunteers, large projects such as clearing acres of French broom, removing ivy from willow thickets, or building stairways or erosion control need focused crews of laborers. The San Francisco Conservation Corps, Shelterbelt, and the former San Francisco League of Urban Gardeners have been hired to help with restoration projects. These young adults, many from at-risk backgrounds, learn teamwork and the techniques and science of restoration ecology. Some of these workers pursue careers in the expanding field of conservation biology.

Most of San Francisco's natural areas are hilltops that avoided the builder's bulldozers. Peaks formed by millions of years of geological subduction dominate the city's landscape. San Francisco's 50-plus hills are the natural features that rise up prominently around the city. The longer one lives in San Francisco, the more the peaks give a sense of place and orientation. Once a person has explored the undeveloped hilltops of Twin Peaks, Corona Heights, and Mount Davidson, and become familiar with them, the more those hills become personal friends. They rise upward like great sentinels overlooking and protecting the neighborhoods. Without these hills, it would not be San Francisco.

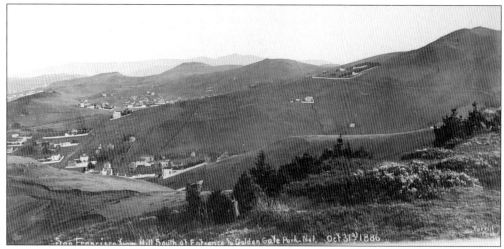

Twin Peaks is seen here at far right from Buena Vista Park in this early photograph. The Spanish-speaking Californios called Twin Peaks "*los pechos de la choca*" or "breasts of the Indian maiden." When Jasper O'Farrell planned Market Street in 1848, he designed the thoroughfare to line up directly with the impressive 900-foot mounds. The peaks are named to coincide with valleys below—Noe Peak and Eureka Peak. The residential communities of Eureka Valley (at left) and Noe Valley (Horner's Addition) can be seen in the background. Note the sensual beauty of the unmolested rolling hills in this 1886 image. (Photograph by Charles Turrill.)

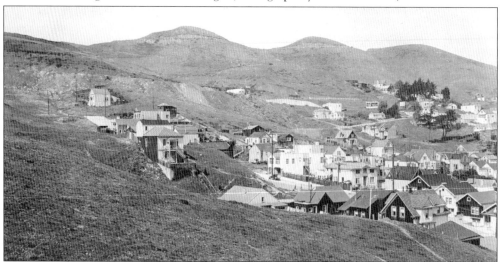

Here is Twin Peaks as it appeared in 1940 from the cliff above Douglass Playground before Clipper Street was extended. The hillside and upper Noe Valley both appear quite rural at this point. Twin Peaks contains small populations of the endangered Mission Blue butterfly, whose prime larval food plant is the silver-leaved lupine (*Lupinus albifrons*). This plant with purple blossoms grows conspicuously on the road cuts adjacent to Twin Peaks Boulevard. Western garter snakes continue to survive on Twin Peaks, while their close cousin, the San Francisco garter snake (an endangered species), does not live in San Francisco. Kestrels (small hawks) regularly hover over the peaks in search of rodents or other small prey. A fantastic array of wildflowers color the peaks in the spring, including long-pedaled iris (*Iris longipetala*), goldfields, mission bells (*Fritillaria affinis*), *Clarkia rubicunda*, three species of lupine, and the rare coast rockcress (*Arabis blepharophylla*) that clings to the "Arabis Cliff" above Burnett Street.

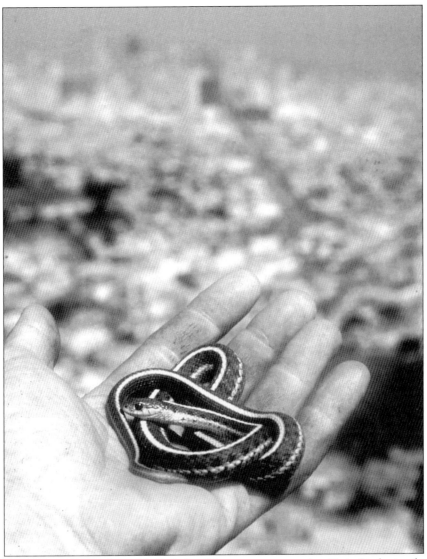

A car on Twin Peaks Boulevard killed this Western garter snake. Twin Peaks is where city planner/architect Daniel Burnham and his assistant Edward Bennett stayed in a temporary Willis Polk cottage to formulate his plan for the beautification of San Francisco in 1904. Due to the earthquake in 1906, most of the Burnham Plan (including a 4,000-acre park from Twin Peaks to Lake Merced, extending the Panhandle to the civic center and a 100,000-seat amphitheater in Cole Valley) was never realized. The uncovered reservoir on the north side of Twin Peaks was constructed to upgrade the city's ability to fight fires after the 1906 earthquake and fire. It was dedicated in 1912 with diving exhibitions and the Presidio band performing patriotic music. The water from the reservoir flows by gravity to a pump house at Clayton and Carmel where it is pumped to fire hydrants. The construction of Twin Peaks Boulevard in 1914 fragmented the natural habitat, while giving the new-fangled automobile access to the summit. The roadway continues to bring traffic, illegal dumping, and death to wildlife. The roadway and the parking lot at Christmas Tree Point (once the site of the city's official Christmas tree) are detrimental to joggers, hikers, and nature lovers trying to enjoy the open space.

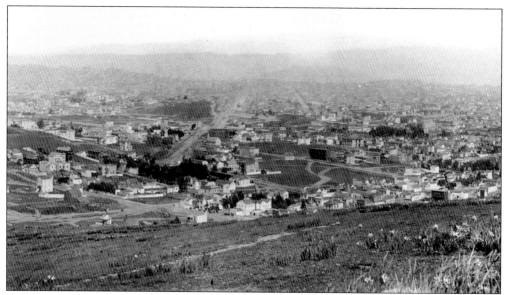

Here is the view from lower Twin Peaks, as seen in the 1880s. Market and Castro Streets met where the grove of trees (the site of a commercial nursery) are located in the center of this photograph.

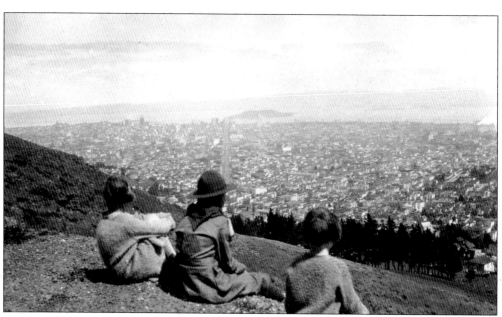

A group of scouts enjoys the great view from Twin Peaks in 1927. (Greg Gaar collection.)

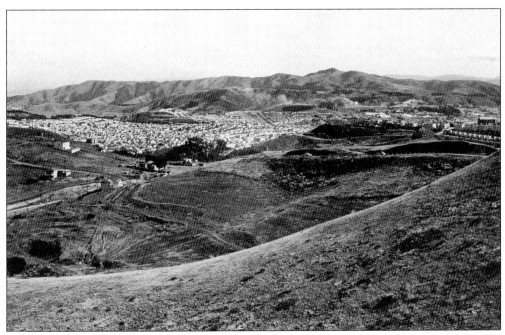

A 1957 photograph depicts the view south from Twin Peaks to San Bruno Mountain.

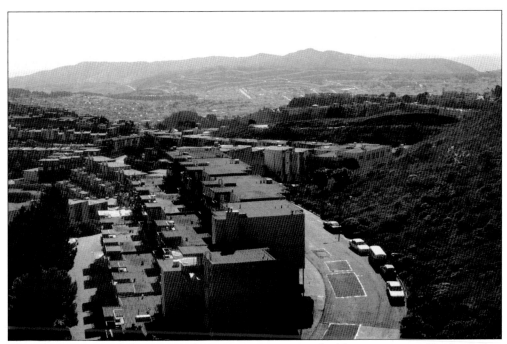

The same view in 1990 shows rows of monotonous apartment buildings constructed by the Gellert Brothers in the early 1960s. (Greg Gaar photograph.)

A photograph of the rural community on Twin Peaks near Twenty-first and Grandview Streets in 1916, before Market Street was extended, shows Red Rock Hill in the background.

A present-day view shows that the Twin Peaks area has now been cut in half by the extension of Market Street. (Greg Gaar photograph.)

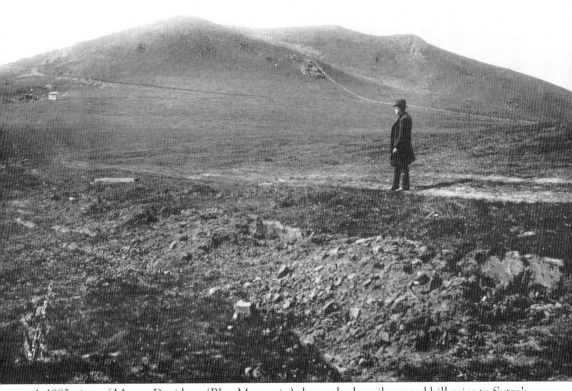

A 1885 view of Mount Davidson (Blue Mountain) shows the heavily grazed hill prior to Sutro's tree planting. Mount Davidson's unforested north slope is one of the city's finest natural areas; the moisture from the fog and the prevailing northwesterly winds have created a unique native plant community that is neither scrub nor grassland. Huckleberry, golden yarrow, pink current (*Ribes sanquineum*), mission bells, snowberry (*Symphoricarpos albus*), nutka or Pacific reed grass (*Calamagrostis nutkaensis*), and Douglas iris cover the steep slope. Raccoon, opossum, skunk, kestrel, and Western garter snakes are residents of this wonderful community. Volunteers and the city's Natural Areas Program have been preserving this primeval site by controlling the nonnative English ivy, Himalayan blackberry, cotoneaster, and eucalyptus so the north slope is healthier today than it was 20 years ago. Inside Adolph Sutro's tree plantation and on the northwest side of the mountain below the cross is a spectacular, perpendicular rock formation that is the "spine" of the mountain. This chert outcrop is covered with the indigenous and rare nutka, which looks like a long beard as it spreads straight down from the rocks and next to the well-traveled trail. Reed Grass populates the north summits of San Francisco's three tallest peaks—Mount Davidson, Twin Peaks, and Mount Sutro. Ranging from Alaska to south of Montara Mountain, tufts of native bunchgrass can grow to four feet tall.

Here is Mount Davidson around 1925 (a similar view as on page 75) with one of the four wooden crosses. Sutro's trees have covered much of the hill by this time. Note the ravine or arroyo where a tributary of Islais Creek flows to Glen Park. Real estate interests have prominently inked Miraloma Park on the mountain. San Francisco's tallest hill was originally named Blue Mountain by scientist George Davidson when he surveyed the hill in the 1850s. Davidson, a naturalist, probably named the hill for the blue flowering plants of blue-blossom ceonothus (now extirpated from the hill), blue-eyed grass (*Sisyrinchium bellum*), Douglas and long-pedaled iris, and others that covered the mountain at the time. Sutro's tree planting in the late 1880s degraded the native-plant community. After George Davidson died in 1911, the Sierra Club lead the effort to have the mountain renamed in his honor. In the 1920s, Madie Brown of the Commodore School Parent Teacher Association pushed to have the city acquire the summit of Mount Davidson for a public park. Children brought wildflowers from the mountain and displayed them at the board of supervisors hearing for the proposed park (the acquisition was approved). Five Easter crosses have been erected on Mount Davidson, and the present, concrete cross was dedicated in 1934. After lawsuits concluded that the city could not maintain a Christian symbol, the cross and the top acreage of Mount Davidson was sold to the Armenian Church. The voters had to approve the sale of any recreation and park department property.

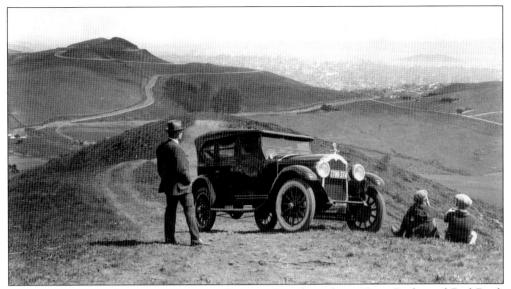

A 1923 view from the eastern summit of Mount Davidson shows Twin Peaks and Red Rock Hill as rural countryside. The small grove of eucalyptus in the center was planted to shelter a German beer garden on the Corbett Toll Road. Today the trees have spread halfway up Twin Peaks. (Marilyn Blaisdell Collection.)

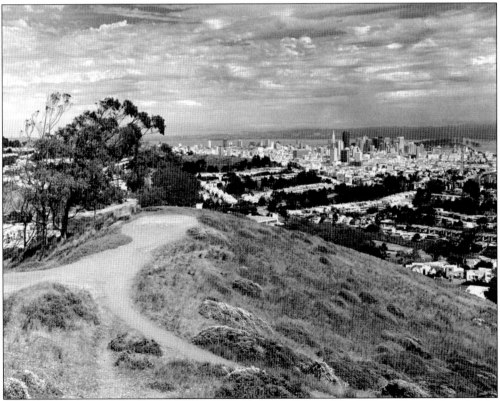

This is a modern view from Mount Davidson's summit, the highest natural point in San Francisco.

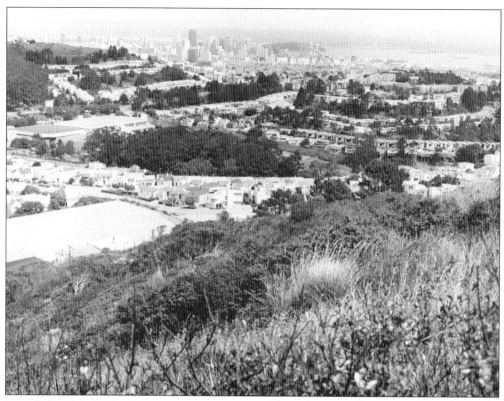

The rich native-plant community thrives on the north side of Mount Davidson. (Greg Gaar photograph.)

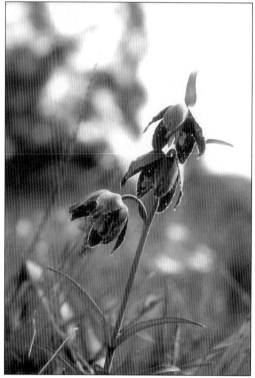

Rare and beautiful mission bells (*Fritillaria affinis*) still grow on Mount Davidson's north slope. (Greg Gaar photograph.)

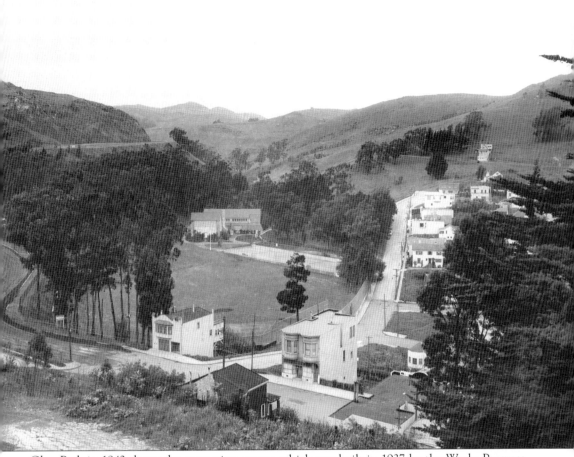

Glen Park in 1942 shows the recreation center, which was built in 1937 by the Works Progress Administration. Twin Peaks and Diamond Heights are undeveloped in the background, and the intersection of Bosworth and Elk Streets can be seen in the lower foreground. Glen Canyon Park is one of the city's finest recreational treasures and an extremely diverse natural area. Containing great chert rock formations, Islais Creek, and steep grasslands, the canyon is an urban naturalist's paradise. The Friends of Glen Canyon Park, under the leadership of Richard Craib and Jean Conner, have mobilized a dedicated group of volunteers, and Islais Creek is being brought back to life. Weedy invaders such as French broom, fennel, and cotoneaster are being controlled. During the spring, Western Garter snakes can be seen slithering across trails near the creek. Red-tailed hawks and great-horned owls nest in the canyon. Plants unique to the canyon include crimson columbine (*Aquilegia formosa*), seep monkey flower, yellow-eyed grass (*Sisyrinchium californica*), and blue elderberry.

Glen Canyon is pictured in 1903, looking to the south. The canyon, once called Rock Gulch, was the site of America's first dynamite factory (ironically, it blew up in 1869). The Mission Zoo was a popular amusement facility in the canyon in 1898 with wild animals, tightrope walkers, balloon ascensions, and dancing to live bands in a red barn. Fortunately, a plan by chief engineer O'Shaughnessy to turn the canyon into a reservoir didn't happen. Some of the land below Marietta Street is still under the jurisdiction of Hetch Hetchy. The Good Brothers Dairy grazed cattle in the canyon during the first half of the 20th century. The construction of O'Shaughnessy Boulevard in the late 1930s did irreparable harm to the natural resources of Glen Canyon. Debris was dumped, causing slide problems that continue to the present. The upper western hills were cut away and fragmented from the lower canyon. Perpendicular cliffs carved for road cuts are now a major slide hazard for motorists. It could have been worse if the proposed 280 Freeway had been cut through the heart of Glen Park Canyon with a tunnel going under Portola Drive. Glen Park neighbors, led by the Blue Gum Ladies, managed to stop the destructive plans of the Division of Highways. O'Shaughnessy Hollow, above O'Shaughnessy Boulevard, was acquired for parkland in the 1990s.

A 1942 photograph looks south across Glen Canyon, showing Islais Creek and various crops. Gold Mine Hill is in the background with a straight row of eucalyptus planted for windbreak. Today most of the north slopes of canyon are densely covered with impenetrable blackberry, poison oak, English ivy, and willows. Starting in 2005, goats were used to clear weedy foliage.

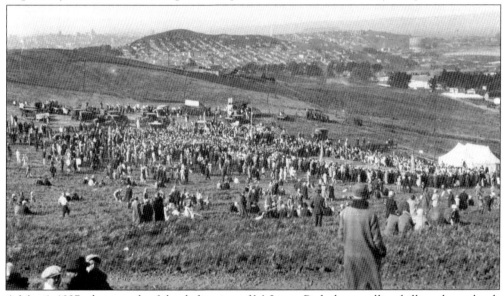

A May 1, 1927, photograph of the dedication of McLaren Park shows rolling hills and grasslands (Bernal Heights is in the background). Native grasses and wildflowers had been heavily grazed by cattle, horses and goats by this time. Imported hay spread nonnative European annual grasses into the native grasslands and these displaced the resident grasses. Planted trees have replaced much of the native-plant communities, and many of these plantations are now impenetrable, dark, and foreboding places where few park users venture. Roadways, such as Mansell Avenue, John Shelly Drive, and Visitacion Avenue were cut through the park in the 1950s and 1960s. The roadways not only fragment what remains of the wildlife habitat in the park, but also are used for illegal dumping and drag racing. About a third of the 350-acre park contains remnant grassland and wildflower fields, although nonnatives are rapidly expanding and displacing the native plants. The best natural areas are to the east of Crocker Amazon Park off of Geneva Avenue and east of the closed viewing tower off of Mansell Street. Yosemite Marsh, a small remnant of a former creek system, is a habitat for the endangered San Francisco forktailed damselfly.

A crew plants a large Monterey cypress in the wildflower fields of McLaren Park in 1928. Today Gleneagles Golf Course occupies the hills in the background where high-maintenance turf has replaced the coastal prairie. (Greg Gaar collection.)

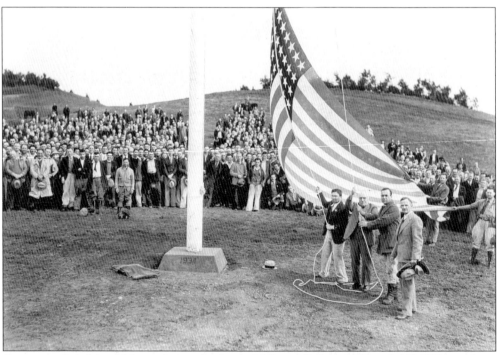

Superintendent John McLaren hoists the flag at McLaren Park in 1933 with 100 WPA workers. (Greg Gaar collection.)

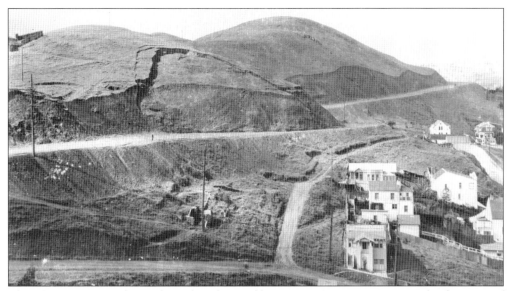

The 25-acre summit of Bernal Heights, depicted here in 1936, is an open-space island in a sea of urbanization. Thanks to volunteer site-stewards Barbara and Roland Pitschel, the Yerba Buena Chapter of the California Native Plant Society, and the city's Natural Areas Program, Bernal's native grassland and wildflower fields are still thriving. Over 40 bird species, garter snakes, 2 species of salamanders, and numerous species of butterflies live in Bernal's grassland. The open space was transferred to the recreation and park department in 1973 at the request of residents. Since Bernal Heights Boulevard was closed to automobile traffic, the walk around the mountain on the roadway has been a joyous experience, providing striking views in all directions. Before closed to cars, it was used for illegal dumping at night and drag racing at all hours. Car tires regularly squashed skunks, raccoons, and opossums. It is easy to improve the quality of life in parks and neighborhoods by simply closing a roadway to motor vehicles. A resident coyote was recently discovered on Bernal.

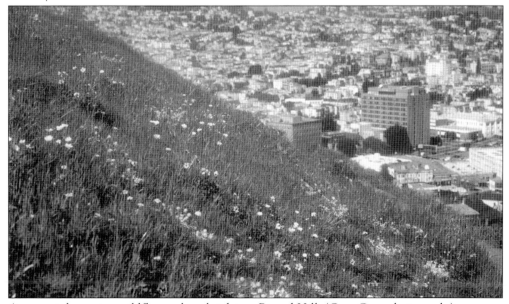

A present-day spring wildflower show brightens Bernal Hill. (Greg Gaar photograph.)

Bayview Hill, a 42-acre jewel in the southeast corner of San Francisco, is pictured in 1924 from Key Avenue. It is a miracle that any of Bayview Hill survives to this day considering that it was quarried, terraced, and cut away for bay landfill to construct Candlestick Park and to expand the Bayshore Freeway (Highway 101). The city planned to use the hill for a "pest house," but the Crocker Land Company refused to donate the land unless the site was used for parkland. The hilltop became a city park in 1915. Much of the public open space on Bayview Hill contains native grassland, wildflower fields, and scrub communities that are populated with a rich array of native plants and animals. On the summit is the city's finest display of Islay, a shrub with a tasty bittersweet cherry that was a mainstay for the native people and a food staple for numerous species of birds. Bayview Hill has a beautiful WPA retaining wall, which is next to a small, rare community of Chinese houses (*Collinsia multicolor*). Native gray foxes have been sighted on Bayview. San Franciscans should explore Bayview Hill, if for no other reason then to look down into Candlestick Park when the native-plant community is most impressive during late spring. *Clarkia rubicunda* colors the north slopes with a reddish pink in early summer. The hill has 19 of the 68 "sensitive" plant species, as described in the Natural Areas Program management plan. The collection is "perhaps the most diverse assemblage of sensitive plants within the Natural Areas System."

Bayview Hill is pictured in 1930 from Bayshore Boulevard.

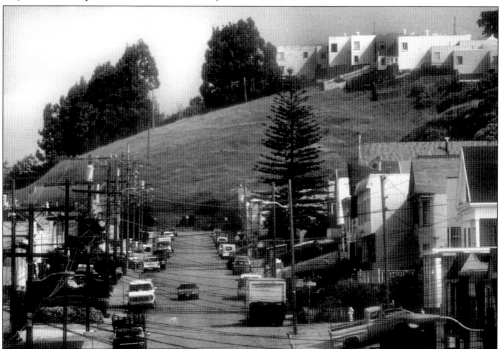

Another grassland slope in the Bayview District is above Palou and Phelps Streets on the north side of Mount St. Joseph. During the spring it is covered with wildflowers. The Caltrain Tunnel, built 100 years ago, goes directly under this natural area. (Greg Gaar photograph.)

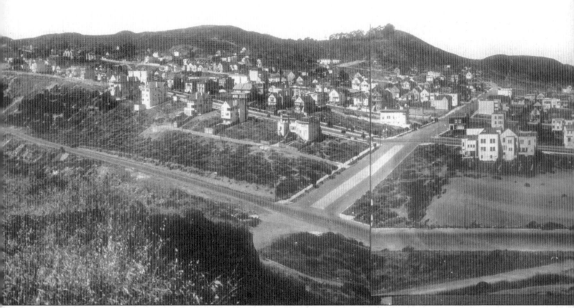

A 1921 panorama taken from Mount Sutro looks to what is now Grandview Park, with the intersection of Seventh and Lawton at lower center. At 800 feet, Golden Gate Heights is where the drifting sand reached its highest point, creating a unique hilltop dune community. By the 1940s, the Sunset District was built and the sand covered intercoastal range of Golden Gate Heights was cut off from its source of sand—the Pacific Ocean. Now the sand erodes off the hills and is swept away by street sweepers or washed down storm drains. As the sand recedes, the chert rock formations created from sediment under the ocean 150 million years ago are being exposed. The intercoastal mountain range of Golden Gate Heights has four prominent natural areas: Golden Gate Heights, Grandview Park, Hawk Hill, and The Rocks (All of these sites were purchased with open space funds). The natural areas on Golden Gate Heights can be explored in a stimulating hike starting at Kirkham Street at the bottom of the Fifteenth Avenue Stairway and up and over the heights. The three lots adjacent to the public stairway between Kirkham and Lawton Streets are dense with native vegetation. Common blackberry and poison oak, mixed with coast live oak trees, mock heather, and an occasional San Francisco wallflower, complete the mix. The view from the stairway of the Inner Sunset, Strawberry Hill, and downtown is impressive. Grandview Park is a sand-covered promontory with a spectacular view of the Sunset District and all of Golden Gate Park is accessed from stairways on Fourteenth or Fifteenth Avenues and Moraga Street. Called "Turtle Hill" and "Pimple Hill" by teenagers who hang out on Grandview, it was one of the early acquisitions in the city's Open Space Program. Though aggressive South African weeds oxalis (sour grass), *erharta erecta*, and iceplant have displaced much of the native dune scrub community, there are good displays of rare dune tansy and the San Francisco wallflower (*Erysimum franciscanum*). Western fence lizards have been seen on the hill and resident hawks and kestrels regularly hunt for small prey.

Here are The Rocks at Fourteenth Avenue and Ortega in a present-day image. The advancing sand never inundated these radiolarian chert formations, but they would have been if the Sunset District had not been developed. It took a major political fight and eminent-domain hearings to acquire the 150 million-year-old geological formation. The rocks are called Franciscan radiolarian chert since one-celled marine creatures called radiolaria are imbedded in the rock. South of The Rocks is Hawk Hill, a southern promontory of Golden Gate Heights directly above Herbert Hoover Middle School. Hoover's school mascot is the hawk. Hawks regularly soar over the dune scrub community of Hawk Hill in search of rodents, snakes, and lizards. Although South African iceplant has overrun most of the lower eastern slopes, much of the hill is still populated with dune plants, such as *Lupinus chamissonis*, San Francisco wallflower, dune tansy, and coast buckwheat. Native succulents of dudleya and sedum cling to the rocks, and the chert rocks are layered with sedimentary as fossilized remnants of a prehistoric ocean floor. It took a political fight to acquire the hilltop with open-space funds, otherwise it would have been covered with expensive housing and asphalt roadways. (Greg Gaar photograph.)

Two photographs, taken from nearly the same spot in 1916 (top) and 1927 (bottom), show rapid development after the Twin Peaks Tunnel opened in 1918. Hawk Hill is in the background, with West Portal of Twin Peaks Tunnel in the valley. These images were taken from Portola and Claremont.

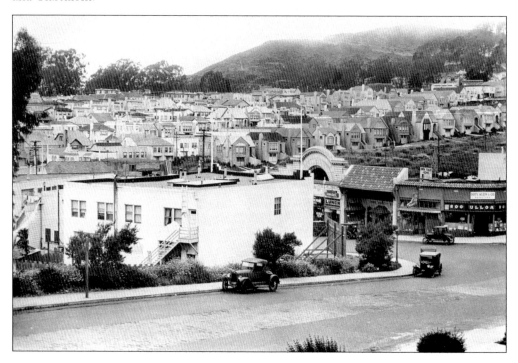

Edgehill Mountain and Mount Davidson are seen here in 1910, looking southeast from the present intersection of Claremont Boulevard and Portola Drive. Not a single house or person can be seen in the photograph, yet today the site is developed and jammed with constant automobile traffic. Though thick with nonnative trees and heavily quarried on its southern face, a portion of the west side of Edgehill is a natural area because the recreation and park land contains some impressive chert rock formations covered with native ferns and succulents. A strong neighborhood group that was active in having the land purchased has been working on restoring this steep slope. Joan Kingery, who passed away in 2003, was the leader and organizer of the Friends of Edgehill Park.

Oak woodland and sand abound in Buena Vista Park in this 1915 image. Today lawns, nonnative trees, and a small children's playground have replaced many of the indigenous oaks. Buena Vista was reserved for a park in 1868 at the same time that Golden Gate Park's boundaries were being determined by the Outside Lands Commission. "Park Hill" was covered by the advancing sandbank and dune vegetation, except in the lower sheltered valley where the oak trees congregated. In 1894, Buena Vista Park was officially dedicated as a city park. Park superintendent John McLaren planted the usual array of cypress, pine, and eucalyptus on the hill, which displaced the dune plants but gave Buena Vista the dense green foliage for which it is known today. Many native oaks survive, but much of the native understory has been choked out by cape ivy and English ivy. Volunteers and the Natural Areas Program are pushing back the weeds and planting oaks and appropriate native understory plants.

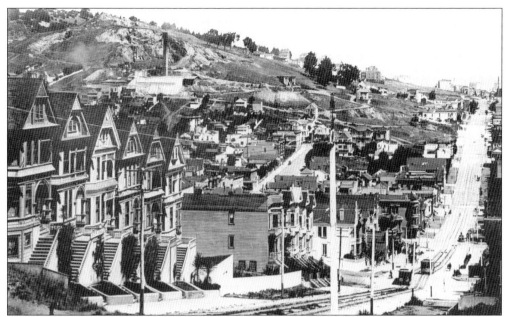

This is Corona Heights in 1900, as seen from the top of Castro Street, with the Gray Brothers brick factory under construction at upper left. Even though about 40 percent of the hill was quarried away by the Gray Brothers between 1899 and 1914 for its chert rock, Corona Heights retains over 50 species of native plants. The foundation of the old brick factory can still be seen above States Street and below the playground on the south side of the hill. The colorful wildflower show in the spring and summer, with the city as a backdrop, is an inspiring juxtaposition for urban hikers. Director of recreation Josephine Randall led the effort to purchase the hill and construct a children's nature museum within the old quarry. Director Randall firmly believed that city kids needed the opportunity to connect with the natural world. Corona Heights has had many names, including "Big Rocky," the Sixteenth Street Hill, and "Acid Mountain" (because hippies enjoyed tripping on LSD there).

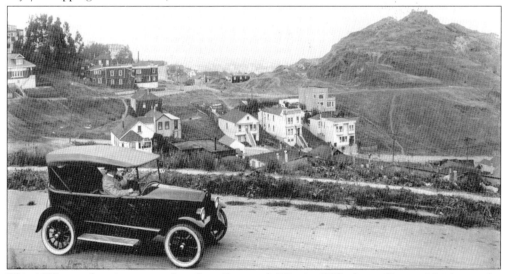

This 1923 car advertisement, taken from Roosevelt Way in 1923, shows Corona Heights in the background. (Randolph Brandt Collection.)

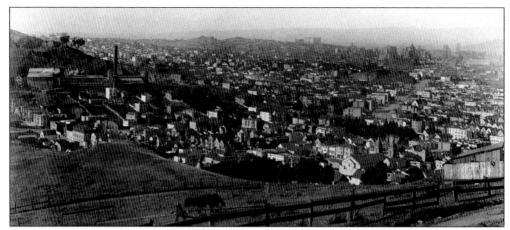

Horses grazed on the future Kite Hill just after the 1906 earthquake, with Corona Heights and the Gray Brothers Brick Factory in the background. Kite Hill, a small but popular grassland hill in Eureka Valley, was originally part of "Nobby" Clarke's Waterworks in the 1880s and 1890s. Old-time Eureka Valley residents recall that it was called Solari Hill, since the farmer Mr. Solari grazed his cattle there. From Kite Hill, visitors can look straight down Market Street to the Ferry Building. Kite Hill was being rapidly consumed for housing when neighbors, led by Doris Murphy, persuaded the city to purchase the remaining lots with funds from the Open Space Program in 1976. The Seward Street Park is a block from Kite Hill and though not a natural area, the open space has a thriving butterfly garden planted by the neighbors as well as steep slide for the kids and kids at heart.

Billy Goat Hill is pictured in the foreground as it looked in the early 1920s. The Gray Brothers quarried the hill until 1914 when an employee shot and killed Harry Gray at this location. Gold Mine Hill, one of the three hills of Diamond Heights, towers over Billy Goat. Gold Mine Hill, Red Rock Hill, and Fairmount Hill were declared blighted areas by the Redevelopment Agency and were bulldozed for housing in the 1960s. In 1954, the Diamond Heights Association, claiming the hills were not a slum or blight area, went all the way to the U.S. Supreme Court in an attempt to stop the development, but the high court refused to hear the association's appeal.

These photographs, taken from the same spot, show the dramatically contrasting view from Thirtieth and Noe Streets to Billy Goat Hill in 1926 (top) and 1984 (bottom).

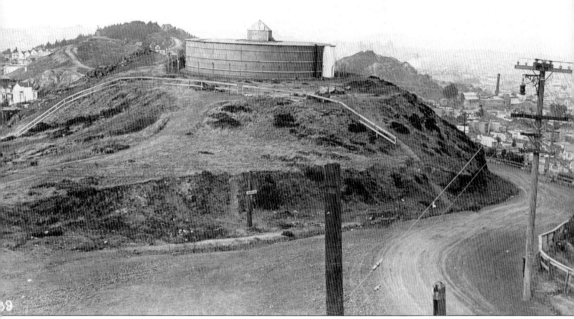

Tank Hill is pictured in 1913 above Clarendon and Twin Peaks, with the hills of Mount Olympus, Buena Vista, and Corona Heights in the distance. Tank Hill is a 2.8-acre, grassland promontory overlooking Cole Valley and Eureka Valley. Named for a long-gone water tank built by the Spring Valley Water Company in 1894, Tank Hill was purchased for $650,000 in 1977. The rocky slope contains over 50 species of native plants as well as garter snakes and Western fence lizards. Tank Hill is being loved to death, however. The little hill is so popular that foot traffic is creating major erosion problems. Volunteers have constructed and maintained a trail system, but many people and dogs do extensive damage by wandering off the trails and trampling the habitat. Wildflower season on Tank Hill is a constant transition of different colors. During February and March, the yellow flowers of footsteps of spring (*Sanicula arctopoides*), biscuit root (*Lomatium*), and California buttercups (*Rununculus californica*) color the slopes. In April and May, Ithuriel's spear (*Tritilea laxa*) and Douglas iris turn portions of the hill blue and purple. In June, farewell to spring (*Clarkia rubicunda*) changes the hill to "Pink Hill." The initial weed threat to Tank Hill's native-plant community, French broom, radish, mustard, and cotoneaster, are under control due to volunteer weeding. This gave expansion room for the indigenous plants and they repopulated the hill. Eucalyptus trees were planted during World War II to conceal the water tank from Japanese planes that were expected to bomb San Francisco. The planes never attacked but the trees remained, spread, and continue to impact the native landscape with shade, fog drip, leaf litter, and by promoting the growth of other weedy species.

Tank Hill is pictured in 1937, as seen from Corbett Road.

This 1918 photograph of Tank Hill, seen from Clayton and Market, shows the tracks of the Eighteenth and Park electric streetcar line. The car reversed its poles to turn onto Clayton. The intersection was called "the switchback."

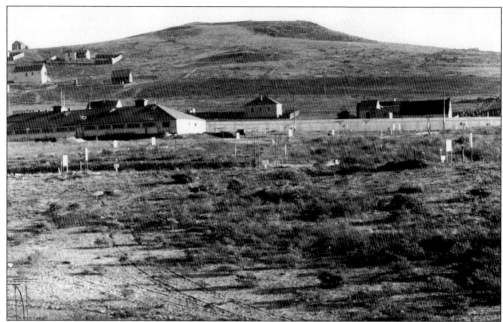

A 1913 photograph shows the entire west ridge of Merced Heights as seen from Ingleside Terrace. Today Brooks Park occupies the summit. This seven-acre open space overlooks Lake Merced and the Pacific Ocean. In the early days, Merced Heights was called Pansy Hill for the native johnnie-jump-ups that cover the open space. Once owned by the Brooks family and now intensely managed by a hard-working volunteer group of neighbors lead by Peter "Crazy Viking" Vaernet, habit restoration has been very successful at Brooks Park. Ice plant, oxalis, and off-road motorcycles have been replaced with an amazing array of native plants, butterflies, and birds. The very diverse OMI (Ocean View, Merced Heights, Ingleside) community has come together splendidly on preserving and maintaining the hilltop park.

Looking north to the Presidio from the present site of Clement and Funston, this c. 1880 image shows drifting dunes, stabilized dunes, and serpentine grassland around the Marine Hospital. Mountain Lake is located in the foreground but is out of view in the valley.

The serpentine bluffs and dune scrub communities above Baker Beach are visible in this c. 1910 photograph by Willard Worden. The Golden Gate National Recreation Area, under the jurisdiction of the National Park Service, oversees the protection and restoration of the natural resources of the magnificent former army base. The Presidio is home to 12 rare and endangered plants, including the rarest of the rare—the Presidio, or Raven's, manzanita (*Arctostapholas hookeri ssp. raveni*), which was on the verge of extinction in the late 1980s. Only *one* plant remained on the planet, and it was quickly losing its sunlight from numerous pine trees that were engulfing it. Fortunately, at the request of the California Native Plant Society, the army removed the trees. The San Francisco manzanita (*Arctostaphylas franciscana*), unfortunately, went extinct in the wild when the last two plants were destroyed. One was in Laurel Hill Cemetery and the other was on Mount Davidson. Botanist Alice Eastwood took cuttings from the cemetery plant, and specimens are displayed at Strybing Arboretum in the Menzies' California Native Plant Garden. Other rare and endangered plants in the Presidio are being propagated and planted in locations where they historically occurred. Those plants include the San Francisco clarkia (*Clarkia franciscana*), San Francisco lessingia (*Lessingia germanorum*), San Francisco spineflower (*Chortzanthe cuspidata var. cuspidata*), dune gilia (*Gilia capitata ssp. chamissonis*), San Francisco wallflower (*Erysimum franciscanum*), San Francisco campion (*Silene verecunda ssp. verecunda*), San Francisco owl's clover (*Triphysaria floribunda*), Marin dwarf flax (*Hesperolinon congestuim*), Franciscan thistle (*Cirsium andrewsii*), San Francisco gumplant (*Grindelia hirsutula var. maritima*), and coast rock cress (*Arabis blepharophylla*). (Marilyn Blaisdell Collection.)

Helmet Rock, pictured here at Land's End in 1910, looks similar to today. Remnants of wrecked ships are visible along the rocky shoreline. Hidden beaches offer solitude for lovers and naturists.

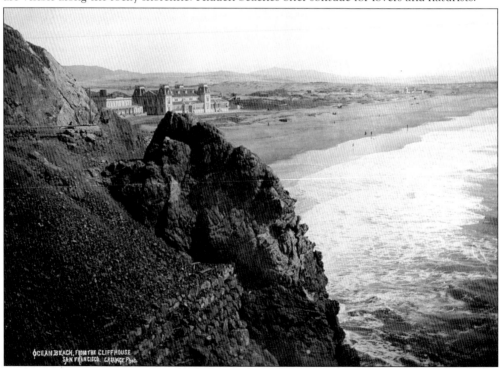

OCEAN BEACH, FROM THE CLIFF HOUSE
SAN FRANCISCO. CREWICK Photo

As seen from Point Lobos around 1880, Ocean Beach stretches for approximately five miles. It is used year-round by surfers, sunbathers, dog walkers, and hikers, and local environmental organizations regularly organize cleanups.

Seven

ISLANDS AND LOCAL WATERS

If there was one place—one site, one source—in which the water formulas and water future of California coalesced in all their possibilities and problems, it was in the San Francisco Bay . . .

Kevin Star, *Coast of Dreams: California on the Edge, 1990–2003*

On the tip of a peninsula, San Francisco has been both impacted and limited by the waters that surround it. The bay is actually an estuary, a place where ocean and fresh waters meet. Many rivers empty into the estuary, intermixing with ocean water to create a variety of sub-habitats. Some marine creatures prefer the saltier waters, while others take advantage of freshwater environments. The waters of the estuary are too cloudy for divers to observe marine life, but one can witness much of the life of the estuary at the Aquarium of the Bay near Pier 39. Wetlands, providing a buffer between the land and water, once lined the whole estuary. Only remnants of them still exist, but restoration efforts are underway. The vistas of the estuary and ocean are breathtaking, and these local waters inspired such writers as Jack London and Robert Louis Stevenson to take voyages and write about far off places. Jack London's semiautobiographical *The Sea Wolf* starts in San Francisco Bay, where he wrote it aboard a boat he owned. The bay is also dotted with islands, such as the semi-artificial Treasure Island, named in honor of Robert Louis Stevenson's classic. The nearby islands are now considered worthy of federal and state protection, having become parkland. Now one can take day trips to Alcatraz, Treasure Island, the Gulf of the Farallones Marine Sanctuary, and Angel Island. To the west of the city are marine sanctuaries.

Seal Point on the Farallon Islands, in an 1882 photograph by Carleton Watkins, is 27 miles west of San Francisco. These small islands host the largest breeding colony of seabirds in the continental United States. In the surrounding waters, the Gulf of the Farallones Marine Sanctuary was established in 1981. In this sanctuary can be found a diverse assemblage of marine creatures, including the great white shark, the California sea lion, the gray whale, the blue and humpback whales, as well as other spectacular sea life. The great white shark and most of the larger species of whales do not swim into San Francisco Bay because they prefer the saltier ocean water.

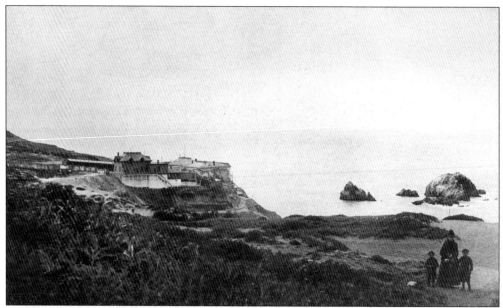

Seal Rock is in the background of this 1880 photograph taken from Merrie Way, with a mother and her two sons in the foreground. A variety of bird life can be seen on outcrop, and it can be observed comfortably from the Cliff House at the northwest tip of Ocean Beach. Observers may see on the rock Steller and California sea lions, as well as harbor seals. (Marilyn Blaisdell Collection.)

The famous Alcatraz stands sentinel in 1895. Before California achieved statehood, Alcatraz Island was the abode for pelicans, and Native Americans ventured to the rocky island to harvest their eggs. Before the island was turned into a federal prison, it was used as a military base to help protect San Francisco Bay from invaders. Now Alcatraz is a national historic site and part of the Golden Gate National Recreation Area. Birds have largely reclaimed the island; one can observe black-crowned night herons, a variety of sea gulls, and other species of birds. The National Park Service staff has let the island become overgrown in certain areas.

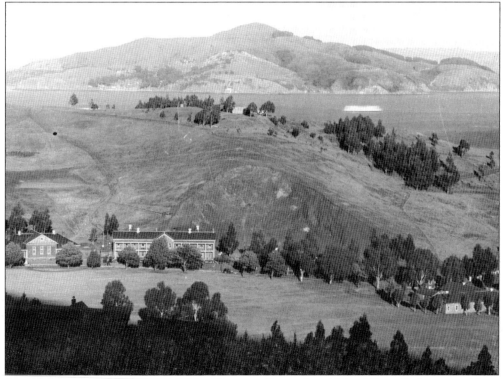

Another year-round destination in San Francisco Bay is Angel Island State Park, pictured here from Marin County in the 1930s. On the island, one can find beaches, a variety of plant and animal life, and spectacular views from the summit.

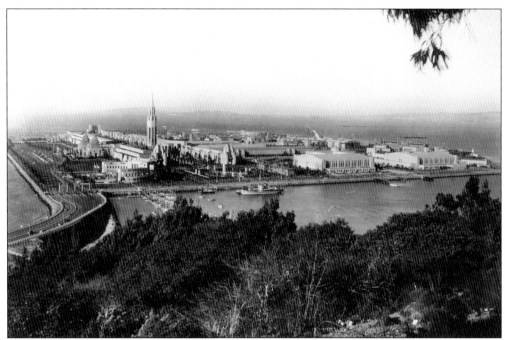

Treasure Island was constructed from a low-lying shoal for a world's fair and navy base. This is a view of Treasure Island from Yerba Buena Island (the larger rocky outcrop next door, though which passes the Bay Bridge's immense tunnel) during the Golden Gate International Exposition of 1939–1940. Treasure Island now hosts an environmental education program, and former navy housing is available for market-rate rents. The island may change radically in the coming years, as redevelopment ideas are considered.

San Francisco Bay is technically an estuary, a place where ocean water mixes with fresh water from various rivers. A variety of marine life takes advantage of the areas. Wetlands once lined San Francisco Bay, but now only five percent of them remain. However, efforts are underway in many parts of the Bay Area to restore them. Wetlands cleanse the bay by providing a buffer between land and water.

Eight

SAN FRANCISCO BIRDS

Over 1,500 California Valley Quail inhabited Golden Gate Park in 1900.

—Joseph Mailliard, *The Birds of Golden Gate Park*

For the bird watcher, there are amazing spectacles to be observed in San Francisco. One can see birds of prey hovering in the airs above Point Lobos Park. Peregrine falcons now make their home on the downtown buildings of San Francisco. Flocks of seabirds and shorebirds rest on Ocean Beach. In the spring, ravens also engage in mating dances in the sky. Brown pelicans fly in formation over Ocean Beach during the summer and fall, diving for fish at the seashore. Terns from far-off places duel in the skies over Ocean Beach. In Golden Gate Park, pigeons feed in huge flocks. Great blue herons and egrets take advantage of the park's lakes, and many migratory birds take advantage of the habitats of the city. The Golden Gate Audubon Society counts all the birds they can find in San Francisco County as part of their annual national bird census. Every year, they find more than 150 species, many of which are rare.

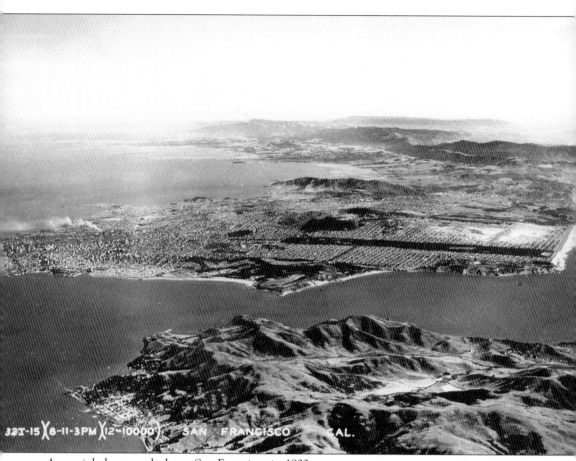

An aerial photograph shows San Francisco in 1932.

At Aquatic Park, one can see brown pelicans flying in formation or diving for fish during the summer and fall. Brown pelicans follow the fish along the West Coast from Baja California to Vancouver Island. (Greg Gaar photograph.)

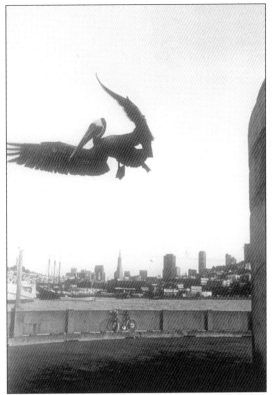

Locally at risk is the western snowy plover, which can be found on Ocean Beach. Dogs often disturb these birds that try to rest on Ocean Beach in order to store the energy they need for their yearly migrations. (Alan Hopkins Collection.)

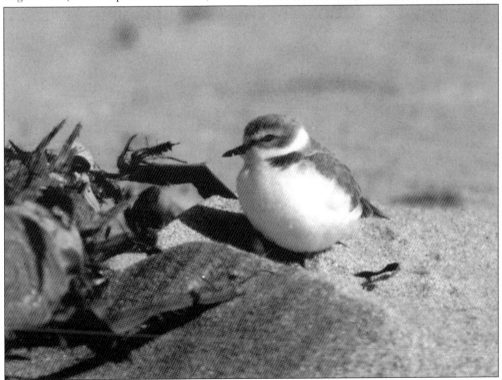

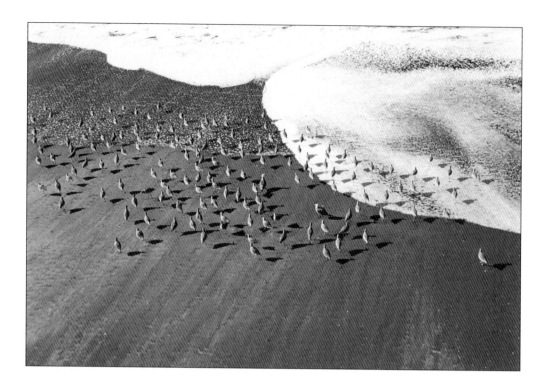

A variety of shorebirds can be observed during a walk along Ocean Beach, including curlews, willets, godwits, sanderlings, cormorants, and terns. (Alan Hopkins Collection.)

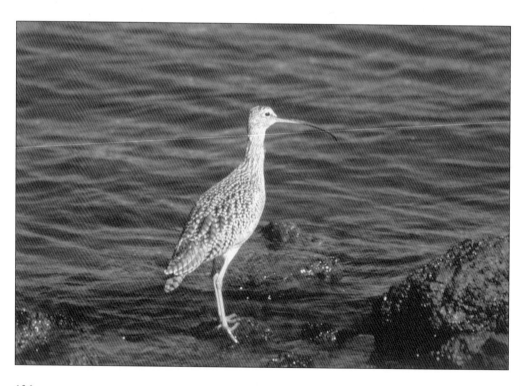

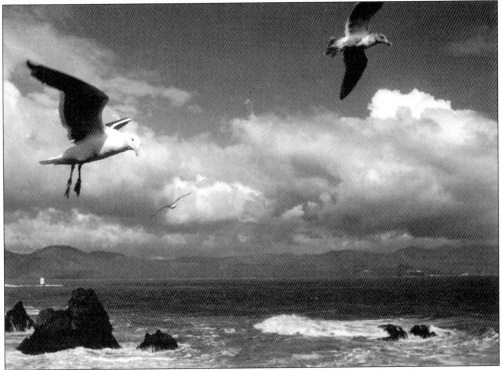

Many species of seagulls can be observed in San Francisco. Usually they are in nearby waters, but not always. (Alan Hopkins Collection.)

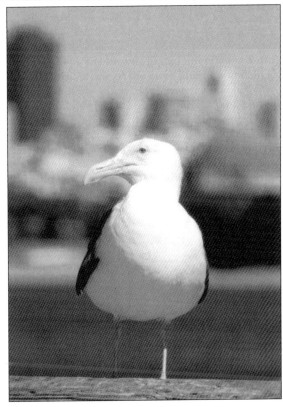

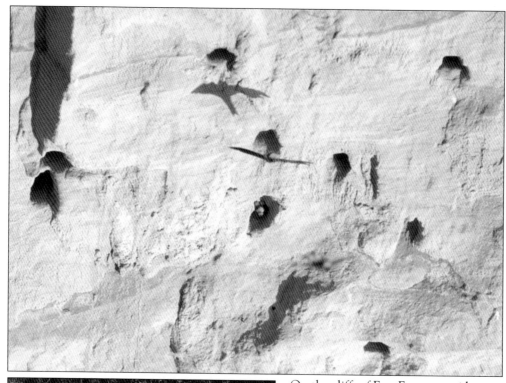

On the cliffs of Fort Funston resides a teeming bank swallow colony. (Alan Hopkins Collection.)

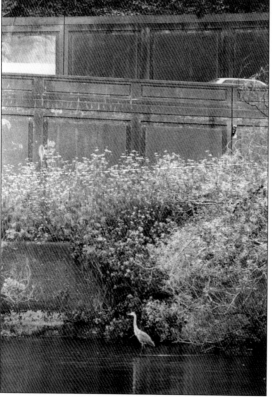

Great blue herons forage Laguna Honda. Egrets can be found on some of the city's lakes. (Greg Gaar photograph.)

San Francisco rivals any urban area in the country as a place to observe life in the air. A diversity of birds can be observed at the Strybing Arboretum, which also showcases a variety of nonnative plants. The San Francisco Recreation Department's Park Natural Areas Program provides nature guides with birding lists for many of the parks in the city.

Local environmentalists continually discuss the plight of the California Valley Quail, whose diminishing populations can still be found in Golden Gate Park and the Presidio. (Alan Hopkins Collection.)

Over 1,500 California Valley Quail inhabited Golden Gate Park in 1900. In 1930, when *The Birds of Golden Gate Park* was published, the most prominent bird in the park was the California Quail, but the impacts of habitat destruction, increased automobile traffic, and feral cats have taken a toll on the official bird of the state and city. The only part of the park where quail now survive is in the Menzies Native Plant Garden in the Strybing Arboretum. Quail habitat is being restored or recreated by the Golden Gate Audubon Society, the National Park Service, the Natural Areas Program, and volunteers in the Presidio and at Harding Park Golf Course by removing weedy species and planting appropriate native plants. In Florence Bailey's 1902 *Handbook of Birds of the Western United States*, she wrote, "The brushy parts of the Golden Gate park in San Francisco abound with quail, and from the benches one can watch the squads of plump hen-like creatures as they move abut with a stately tread or stand talking sociably in low monosyllables."

THE BIRDS OF GOLDEN GATE PARK

San Francisco

Mailliard

Also to be observed on the lakes of Golden Gate Park are ducks, coots, and sometimes a variety of other birds. (Alan Hopkins Collection.)

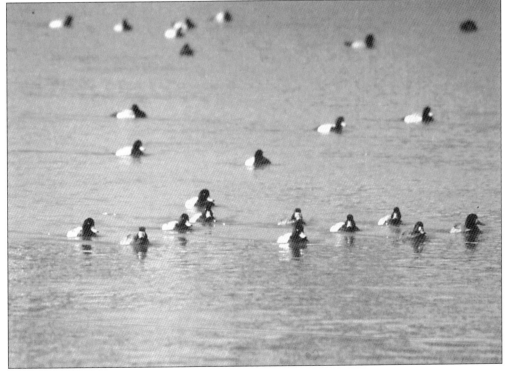

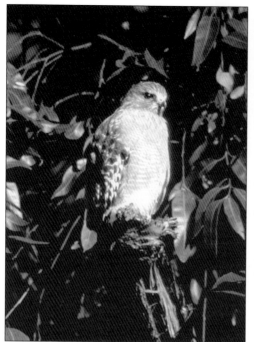

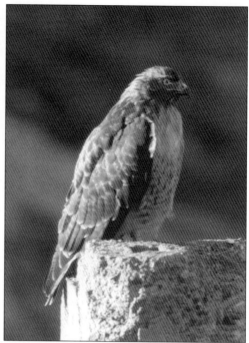

From the Northwest tip of the city at Point Lobos, one can look over the city and observe raptors flying along the Pacific flyway. (Alan Hopkins Collection.)

The green spaces in San Francisco host Brewer's blackbird. The male of the species has yellow eyes, a purplish tint on the head, and a green tint on the body. The females are brown. Red-breasted robins also abound in the city. (Alan Hopkins Collection.)

In abundance in San Francisco are pigeons, starlings, and the English/House sparrow. These birds are inquilines, or species that live in the nests of other creatures. These birds have adapted to live in the "nest" that is the urban and suburban landscape. The relationship started in the old world, and they have been living with mankind for thousands of years. They were introduced to America and, like humans, have caused environmental problems by being too successful. (Alan Hopkins Collection.)

A bird of concern in San Francisco is the Northern raven, which has increased in population throughout the Bay Area. They have been successful because they are intelligent, opportunistic generalists who eat human refuse, and their natural predators have been removed from the food chain. (Alan Hopkins Collection.)

Nine

EARTHQUAKES

There was a deep rumble—deep and terrible, and then I could actually see it coming up Washington Street. The whole street was undulating.It was as if the waves of the ocean were coming towards me and billowing as they came.

—Police sergeant Jesse Cook,
on duty in the Produce District during the 1906 earthquake

San Francisco is a city of hills, but surrounding it are jagged lines of space between large plates of earth. These crevice edges are continually sliding past each other, but sometimes their movement is so enormous and intense that it causes an earthquake. During an earthquake, the ground doesn't just shake, it actually shifts permanently (at least until the next quake), causing miles-wide swaths of land to continue the wave of motion.

During the 1989 Loma Prieta earthquake, which occurred south of the city along the San Andreas fault line, so much land shifted that fires started in the San Francisco Marina neighborhood at the same time Candlestick Park, south of the city, rose up and came down. And between and outside of those two locations, highways fell, including parts of the Bay Bridge and a double-decker thoroughfare in Oakland. Portions of the city of Santa Cruz were devastated as well.

The three main Bay Area fault lines are The San Andreas, Hayward, and Calaveras. The San Andreas is the best known, and it runs from San Juan Bautista up to Daly City. This fault continues underwater and is what separates the Point Reyes Peninsula from the mainland; it continues north to Tomales Bay. Movement along this fault caused the famous 1906 earthquake that devastated the city.

The Hayward Fault runs north to south in the East bay from Fremont in the East Bay, following Highway 580 into Berkeley, and the goes down toward the Diablo Range. It joins the San Andreas Fault near Hollister.

The Calaveras Fault branches eastward from the Hayward fault near Gilroy. It runs in a fairly straight line to Vallejo and possibly all the way to San Pablo Bay. Researchers are still trying to determine its length. At any rate, a fault need not be in San Francisco's city limits to cause damage there.

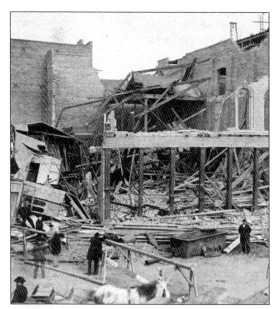

San Francisco is located on the Pacific Plate and along the "Ring of Fire," where earthquakes and volcanic activity are natural occurrences, allowing the planet to expand and contract. Earthquakes have not only sculpted the hills, valleys, lakes, and bays of the region, but they also give San Franciscans an ongoing relationship with the awesome power of Mother Earth. Scores of books have been written on seismic events in California, but this photographic book would be less than complete without some striking images of San Francisco earthquakes. The October 21, 1868, earthquake occurred along the Hayward Fault in the East Bay, but San Francisco's stone and brick buildings were impacted. This photograph by Carleton Watkins shows significant damage at Market and First Streets.

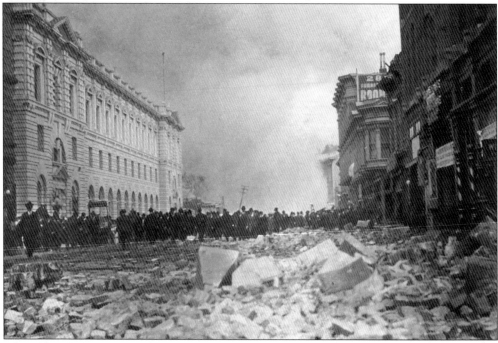

The "Great Quake" of Wednesday, April 18, 1906, struck at 5:13 a.m., when 300 miles of the San Andreas Fault shifted. Gas lines broke, electrical poles and live wires fell against wooden structures, and wood stoves turned over. Major loss of life and numerous fires occurred in collapsed rooming houses south of Market Street, and fires broke out in the Produce District, spreading into Chinatown and the Financial District. Water mains ruptured, preventing most efforts by the fire department to control the fires. This photograph, taken in the late morning of April 18, is looking south on Seventh Street to Mission Street with the post office at left (incidentally, the post office still stands today). Fallen debris covers the street, and fires from the "South of the Slot" are heading north toward the photographer.

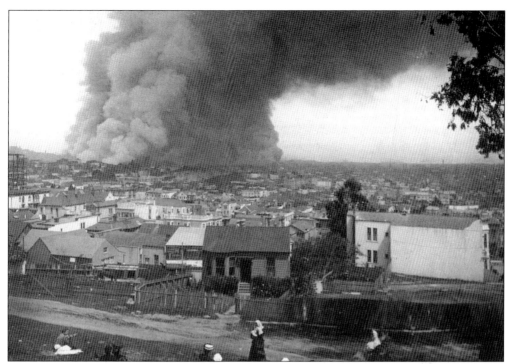

This view from Corona Heights above Fifteenth and Beaver Streets, shot at 2:30 p.m. on April 18, 1906, shows that fires from South of Market, the Financial District, and Hayes Valley are merging into a huge conflagration.

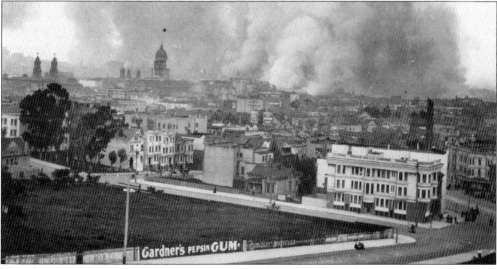

This photograph, taken on the late morning on April 18, 1906, shows the intersection of Hermann, Laguna, and Market Streets. Fires are beginning to merge, but the South of Market fires have not yet engulfed Market Street. Landmarks on the skyline waiting to burn are St. Ignatius Colleges at Hayes Street and Van Ness Avenue (left), City Hall (left center), and the already-destroyed chimney of the powerhouse for the Haight and Castro cable car barn at Valencia and Market Streets (lower right). The prominent white apartment building at lower right still stands today, though all other buildings on that side of Market Street burned to the ground.

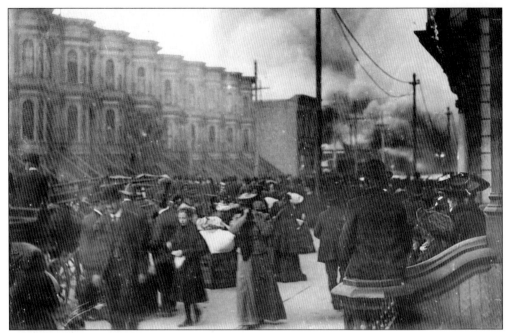

As the fires spread, residents in many cases had very little time to collect cherished possessions. San Franciscans risked being shot for looting if soldiers or the National Guard saw residents going into homes. This image shows a calm retreat as the fire approaches, though the row of Italianate Victorians will be ideal kindling for the flames.

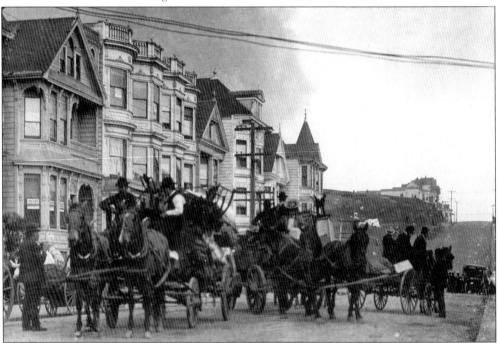

Here is another photograph of San Franciscans fleeing the fire, with the west side of Russian Hill in the background. As the blaze advanced into the neighborhoods, people were heard saying, "Eat, drink and be merry, for tomorrow we may have to move to Oakland."

A lack of horses didn't prevent these refugees from saving some mementos.

Refugees that escaped the fire had no choice but to huddle in city parks. After the city burned for three days, 250,000 homeless (out of a population of 450,000) would live in parks, open spaces, and military reservations. This photograph shows Hamilton Square in the Western Addition, with Geary Street and a damaged Girls' High School in the background. The landscaped hill is Calvary Cemetery, the present location of Kaiser Hospital and the Anza Vista neighborhood.

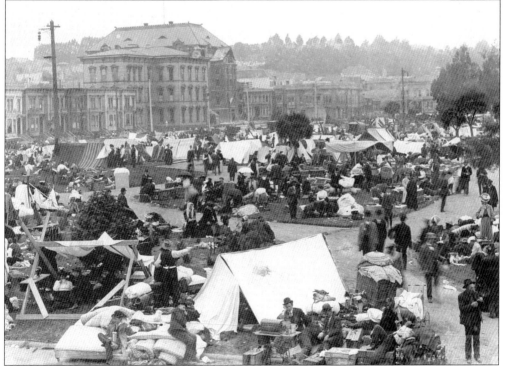

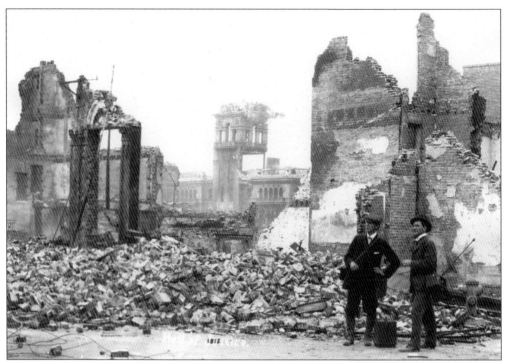

After the destruction, sightseers and photographers roamed the "damndest finest ruins." Here are two photographers getting their likenesses recorded in what was Chinatown. The remains of the Hall of Justice on Portsmouth Square are the background.

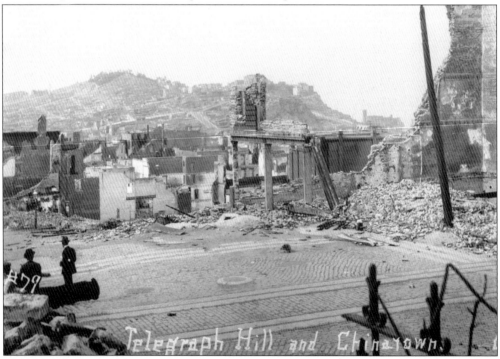

This is another view of the total destruction of Chinatown, with Telegraph Hill in the background.

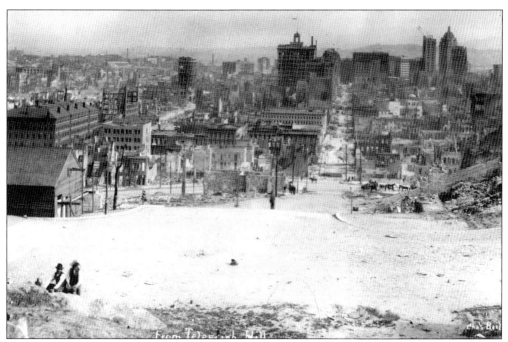

A photograph taken from Telegraph Hill at Montgomery and Vallejo Streets looks south toward the Financial District. Except for the Appraisers Building, at left, and the Montgomery Block (present site of the Transamerica Pyramid), every structure is burned to the ground or gutted. The financial center of the West Coast is literally gone. Within three years, everything would be rebuilt.

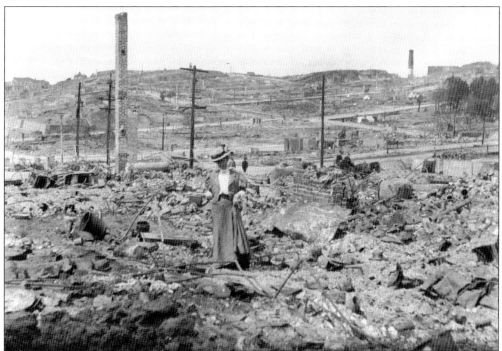

Posing in the rubble, a lady stands near Polk Street with Russian Hill in the background.

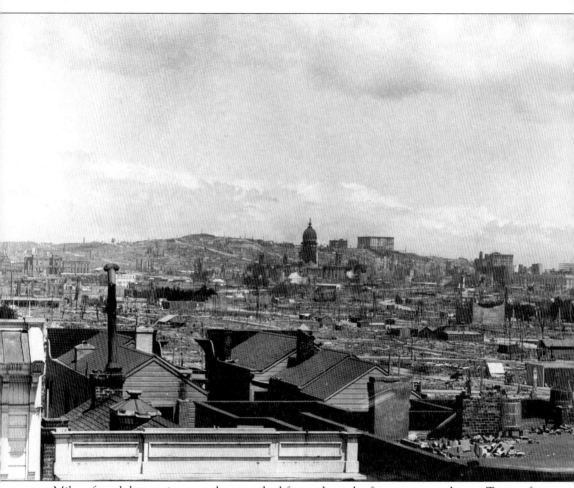

Miles of total destruction was photographed from where the fire was stopped, near Twenty-first and Guerrero Street. The gutted city hall and Fairmont Hotel are prominent in the center of photograph. Nearly 3,000 died in San Francisco, and 500 blocks were destroyed. The devastation included all of South of Market, the Financial District, North Beach, Chinatown, Polk Gulch, and most of Telegraph Hill and Russian Hill, and half of the Mission District.

The moderate Loma Prieta earthquake of October 17, 1989, was the largest Bay Area temblor since 1906, but still small in comparison. If today's population of over six million people had been living in the Bay Area in 1906, tens of thousands would have died. This photograph shows damage near Embarcadero Center to a 1907 building. Nearly all the damage in San Francisco in 1989 was on bay fill, or where lakes or creeks had been covered.

The Ferry Building was a major symbol of San Francisco in 1906 and was symbolic in 1989 as well. The flag pole is tilted and the iconic clock has stopped at the time of the quake. The removal of the quake-damaged Embarcadero Freeway would reconnect the Ferry Building with the city.

Appendix A

THE POLITICS
OF PRESERVATION

After 200 hundred years of intense urbanization, San Francisco still has parks and open spaces with flora and fauna that were part of the original landscape. Starting in 1974 with the passage of the first of three voter-approved Open Space Acquisition and Park Renovation Programs, citizens and city government began the purchase of numerous hilltops and open spaces that would inevitably be called natural areas. Though the recreation and park department was responsible for taking care of these remnants of the original landscape, the city had never managed these living museums to preserve their unique biological diversity. In the late 1980s, local chapters of the Audubon Society, the California Native Plant Society, the Sierra Club, neighborhood groups, and concerned environmentalists convinced city government to take an active role in preserving San Francisco's natural heritage. After many public meetings and hearings, the planning commission and the recreation and park commission adopted Policy 13 of the Recreation and Open Space Element of the General Plan—"Protect and Preserve Significant Natural Areas."

The two greatest hazards to preserving natural areas are the threat of development if the site is privately owned and the risk of invasive, exotic plants (weeds) that can destroy a public natural area as effectively as if bulldozers had scrapped the land away. The Natural Areas Program (NAP) began managing the 30 natural areas in the recreation and park system in 1997. NAP's work was based on a recreation and park commission-approved directive to control weeds that threatened the native species of these areas. The work scope was based on successful management practices of the National Park Service in the Presidio, Fort Funston, and the Marin Headlands. Objectives for habitat restoration include controlling the weeds, propagating and planting native fauna, reducing erosion with a good trail system, and educating the public with interpretive signage. Starting in late 2000 as a reaction to the dog policies in both federal and city parks, an organized effort by off-leash dog advocates tried without success to kill or cripple programs that are responsible for managing San Francisco's wild lands.

Hearings upon hearings have been held on the topic of habitat restoration and although there is a small, hardcore group that oppose using public resources to preserve San Francisco's natural areas, anyone who researches the importance of restoring the natural systems or volunteers in restoration work parties quickly becomes an advocate for preserving nature in the city.

Habitat restoration is a relatively new science and a new way of thinking. People fear change. Repairing the damage that humanity has done to the earth's ecosystems means the human species will have to curtail some activities to enhance nature. Reducing parking lots in Yosemite Valley, stopping off-road vehicles in coastal dunes and deserts, or reducing some off-leash dog activity at Fort Funston are minor sacrifices when everyone benefits in experiencing a healthy and thriving natural area.

Appendix B

VOLUNTEER
OPPORTUNITIES

Throughout San Francisco and around the world, government agencies and volunteers are working in partnership to preserve and repair the health of the earth's ecosystems. Type in "habitat restoration" when surfing the Internet, and one will witness the revolution in the attempt to repair earth's ecosystems. Restoration is not a fad; it is a crucial responsibility that will preserve the world's health for future generations of plants, animals, and people. Get on the bandwagon.

San Franciscans who want to protect the Amazon rainforests, the gorillas in Africa, or the ecology of the Alaskan tundra can give money to these important efforts. Yet in San Francisco, there are numerous opportunities where a person can preserve native habitat, whether its the coastal scrub of Twin Peaks, the native oak woodlands of Golden Gate Park, the serpentine grasslands of the Presidio, or the purity of Mountain Lake.

The Natural Areas Program is managing 1,000 acres of native flora and fauna. NAP staff encourage volunteers to help control weeds and plant native vegetation. Volunteers range from individuals to school groups, to church groups, to businesses or corporations. To get involved, call the NAP at (415) 753-7268.

The National Park Service promotes volunteerism throughout the vast Golden Gate National Recreation Area, including the Presidio and Fort Funston. Go to the Presidio or the Golden Gate National Recreation Area Web site or call the volunteer hotline at (415) 561-4755.

The Yerba Buena chapter of the California Native Plant Society (www.cnps-yerbabuena.org) has monthly presentations at the San Francisco County Fair Building. CNPS sponsors work parties, advocates for preserving nature in Northern San Mateo and San Francisco Counties, and works with other chapters throughout California to preserve the states unique native flora. A new organization called Nature in the City (natureinthecity.org) advocates for natural areas and organizes work parties.

San Francisco native plants can be purchased at the Haight-Ashbury Recycling Center at Frederick and Arguello, next to Kezar Stadium, seven days a week. Strybing Arboretum and the California Native Plant Society also have periodic sales.

WHY VOLUNTEER?

Volunteers learn what native plants are food for the native animals.
Volunteers learn why plants become invasive and how to control weeds.
Volunteers learn to propagate seedlings in the nursery.
Volunteers make friends with staff and other volunteers.
Volunteers enjoy watching wildlife return to the land that they manage.
Volunteers experience spiritual intimacy with Mother Earth.

BIBLIOGRAPHY

Baker, Malcolm E. *San Francisco Memoirs 1835–1851*. Londonborn Publications, 1994.

Bauer, Nancy. *The Habitat Garden Book—Wildlife Landscaping for the San Francisco Bay Region*. Mendocino, CA: Bored Feet Publications, 2001.

Brechin, Gray. *Imperial San Francisco: Urban Power, Earthly Ruin*. University of California Press, 1999.

Brooks, James, Chris Carlsson, and Nancy J. Peters, eds. *Reclaiming San Francisco: History, Politics, Culture*.

Brosnan, William. *The Earth Shook, The Sky Burned*. 1959.

Clary, Raymond H. *The Making of Golden Gate Park*. Lexicos, 1985.

Gilliam, Harold. *The Natural World of San Francisco*. Doubleday, 1967.

Holloran, Pete. *Seeing the Trees, Through the Forest: Oaks and History on the Presidio*.

James Roof interview. Helen Crocker Russell Library at Strybing Arboretum. San Francisco.

Lockwood, Charles. *Suddenly San Francisco: The Early Years of an Instant City*. San Francisco Examiner Division of the Hearst Corporation, Special Projects, 1978.

Margolin, Malcolm. *The Ohlone Way*.

Mailliard, Joseph. *Handbook of the Birds of Golden Gate Park, San Francisco*. San Francisco: California Academy of Sciences, 1930.

Mayfield, David. "Ecology of a Discovered Land." *Pacific Discovery Magazine*, September/October 1980.

Miller, John. *San Francisco Stories*. Chronicle Books.

Myrick, David F. *Telegraph Hill*. 2001.

"Natural Areas Management Plan" (draft); EIP Associates, June 2002.

Olmsted, Nancy. *Vanished Waters: A History of San Francisco's Mission Bay*. Mission Creek Conservancy, 1986.

Rare and Endangered Plants of San Francisco's Wild and Scenic Places, California Native Plant Society; Compiled by Mike Wood, 2000.

The Adolph Sutro Estate Properties. San Francisco: Baldwin and Howell Real Estate, 1910.

The Flora of San Francisco. University of San Francisco, 1958

The San Francisco Chronicle. *The Hills of San Francisco*. San Francisco: The Chronicle Publishing Company, 1959.

ACROSS AMERICA, PEOPLE ARE DISCOVERING SOMETHING WONDERFUL. *THEIR HERITAGE.*

Arcadia Publishing is the leading local history publisher in the United States. With more than 3,000 titles in print and hundreds of new titles released every year, Arcadia has extensive specialized experience chronicling the history of communities and celebrating America's hidden stories, bringing to life the people, places, and events from the past. To discover the history of other communities across the nation, please visit:

www.arcadiapublishing.com

Customized search tools allow you to find regional history books about the town where you grew up, the cities where your friends and family live, the town where your parents met, or even that retirement spot you've been dreaming about.